SS COLLECTION

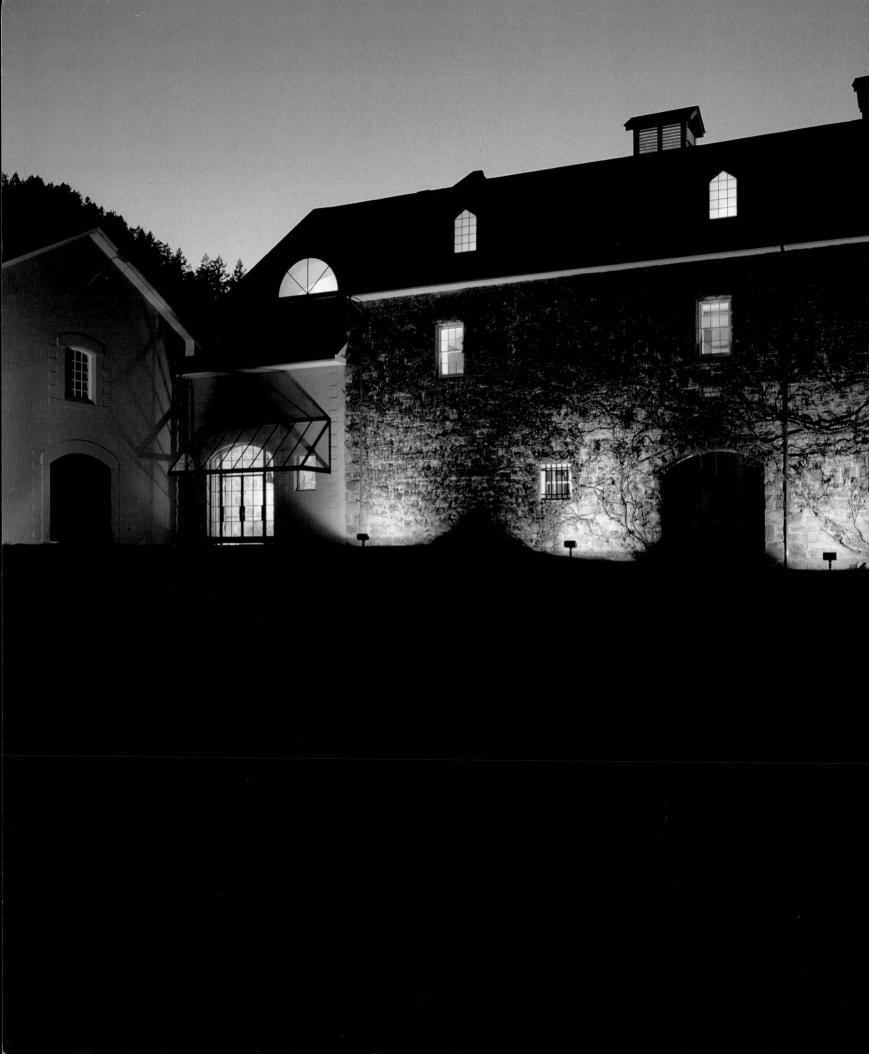

Dieter Ronte

HESS COLLECTION

Harry N. Abrams, Inc., Publishers, New York

Hess Collection

4411 Redwood Road · Napa, California 94558

Foreword

I love contemporary art because it speaks in images of our time. It is a mirror of the age in which we live and reflects the sensibilities of people of perception who have a great deal to say to us. Art today will often open up the inner world of the artist's most private experience to those who have eyes to see. Admittedly, there are artists who do not make it easy for us to understand their work. However the same is also true of modern music and modern literature. Sadly, a lot of people cling to the belief that only the art of past centuries is worthy of their appreciation and that anything else is impossible to understand. They forget that the contemporaries of Turner, Goya, van Gogh and the Impressionists were equally mystified by their paintings and reacted to them with disapproval or dismay. An artist is often decades ahead of the average aesthetic understanding of those around him. In any case, artists these days are not interested in being accommodating; what they want is to set new trends and to do so in a manner that is uniquely their own.

Whenever the subject came up in conversation of how the general understanding of contemporary art might be improved, Johannes Gachnang (director of the Kunsthalle in Bern from 1974 to 1982) would say with an ironical smile: "You wouldn't dream of expressing an opinion about a book after a brief glance at the dust cover, but that's what happens with contemporary art."

Years ago, when the Danish artist Per Kirkeby had an exhibition in Bern, Gachnang saw that I was having difficulty finding any kind of access to his work. He suggested that I go round the exhibition one more time, pick out the painting I could do most with and then sit and look at it closely for half an hour. I did what he advised, but I still couldn't grasp Kirkeby's meaning. Four years later, when I was beginning to be seriously interested in this artist's work, I happened to come across that same "Kunsthalle" painting in a German gallery (p. 103). Suddenly I felt a strong attraction to this painting and started from then on to collect Kirkeby.

It was exactly twenty years ago that I first began to take an interest in contemporary art and started buying paintings by artists who were known to me. It soon became clear that in view of the enormous number of excellent and interesting artists all over the world, I would have to work out some kind of method of procedure. The system I conceived then for the purchase of works of art is the one I am still using today:

– I only collect works by living artists, whose work has been known to me for some time. I rely on my own eyes, on my intuition. The work must awaken a profound response in me. I am not impressed by current trends or fashions, nor does it really matter to me how well known the artist is. I think very long and hard about a painting before I decide to buy it. Once I have reached the stage

where the excitement is beginning to keep me awake at night, then I know for sure that I am seriously involved with that particular painting and hope I will soon be able to add it to my collection.
– I limit myself to something like twenty artists, so that I can go on buying their paintings at regular intervals and thus build up a representative body of their work.
– It is very important to me to have a personal relationship with the artist.

Collectors have a continuing responsibility to the artist after they have bought one of his works. It is up to them to defend the work on its creator's behalf against an often uncomprehending outside world. It is also their responsibility to take expert care of the work of art and so ensure that it is preserved for future generations. Finally, the work should be made accessible to as large a public as possible, particularly after an artist and his work have achieved a certain degree of recognition.

Until recently, collecting contemporary art was my secret passion, known only to my family, a few friends and artists; thanks to this catalogue, and to the exhibition rooms in "The Hess Collection Winery" in Napa, that will inevitably change. It gives me great pleasure to see the works of the more established artists of my collection assembled for the first time under one roof, after years of being housed in different places because of a lack of space.

In addition to the permanent collection, other activities are planned. We want to give young artists the opportunity to present concerts and performances. There are also plans for courses and lectures on the cultural exchange between Europe and America. Autumn 1989 will see the start of an annual film and video cycle devoted to international artists. All these activities will be funded by the recently established Napa Contemporary Arts Foundation, under the expert direction of Leopoldo M. Maler.

I hope that our American visitors will take great pleasure in discovering European art, or in renewing their acquaintance with it.

I should like to thank my friends Christian Cuénoud, Johannes Gachnang and Veith Turske for the many stimulating discussions that we have had together over the years and which I have always found extremely helpful.

My thanks go also to Dieter Ronte for his collaboration and for his essay "Art Experiments". It was a pleasure to work with him on the preparation of this catalogue.

To my wife Joanna and my daughter Alexandra I would like to express my warm and grateful thanks for their readiness to share their home for years with difficult paintings and sculptures. It was also Joanna's idea to house the collection in the old stone winery in Napa.

Donald M. Hess

Bern, November 1988

Contents

The Hess Collection: Art Experiments

Vineyards are intensive by nature: growth, harvest, work – there is intensity and yet with it, peace and permanence. Vineyards are remarkable places. They hold the promise of something exceptional.

A museum is also a place where the extraordinary is the norm. It houses things that are precious but in a very exceptional kind of way. An art museum is a treasure chamber, guardian over objects that are intensively aesthetic and precious. A place where things can be seen that are special and rare – the opposite of the everyday.

Set in a beautiful natural landscape, the museum that houses the Hess Collection has on exhibit works of art put together in a way which is unique in the United States. The collection draws a comparison between art in Europe and art in the United States since 1950. Two continents are brought together here, and they have a lot to say to each other.

And still the experiment is extremely unusual. Europe has long been neglectful of American art, even to the point of denying its existence. America on the other hand has looked continually across to Europe, and to Paris in particular, while hesitating to make its own position completely clear. It has only been in the last thirty years that a fruitful exchange of ideas has begun to be established. Aesthetics found a foothold where political ties were growing stronger – with no thought whatever of cultural colonisation. Dialogue presupposes independence.

Art is communication. If we know more about each other now, it is not only thanks to our political connections, but also to the way the media contour the landscape of our time. Ties on a global scale, an awareness of how small the world is, have contributed to making the age we live in an interesting one. We can fly to the moon, but we cannot ultimately escape from our earth. The globe brings us closer and closer together; what we have in common is challenged to stand forth and declare itself.

The old dream of trading in ideas (Madame de Staël) is admirably fulfilled in the Hess Collection. The private collector forges ahead. The individual collects in order to show his collection later to the public, as here in the Napa Valley. Against the hard realities of media exposure he sets the creative imagination of the artists. Between the two a very different perspective on art emerges in which the pluralism and the contrasts in modes of human expression become apparent, but also the similarities, the common denominator. The private collector is prepared to take risks.

This is not to say that Donald Hess collects in an encyclopaedic kind of way, aspiring, so to speak, to a totality of information. Hess collects like a good private collector, namely with a deliberate and consistent eye to his own personal needs and preferences. He acquires what is relevant to himself. He looks for works of art that will stimulate him personally. In dialogue with them his own

intellectual energies are released. For him the work of art is a challenge, a partner and at the same time an initiate. The Hess Collection has artists whose works have something challenging about them. The artefacts pose questions and provide answers to questions put to them. The search for beauty in art does not mean only collecting what reaffirms and is affirmative, but also things that are still in search of affirmation, which are challenging because their character is progressive.

The museum of the Hess Collection is a place where we can learn.

What can we learn? Old ideas of beauty are no longer valid today. Art has gone public. Art is on the offensive. Art asks questions. New art is always different from what the public at large takes it to be. Art means freedom. And freedom involves hard work and not just pleasure. Art does not provide affirmation. Art is alive to new departures, is enterprising, adventurous. Artists seek the Other, that which so far has always remained unrevealed, not what we are all familiar with already. Art looks for points of contact with the unknown. Art is a venture; it loves to experiment.

The collector, whose business takes him back and forth between Switzerland and California, is fully aware of the difficulties involved in understanding modern art. As a man of action, it is incumbent on him no less than on the artist to tread new paths. This is why he loves art. Pictures and sculptures of the

quality of the Hess Collection cannot fail to stimulate, precisely because they are difficult and disturbing.

To experience this collection is to have the most pleasant of encounters with the problems of our time. The artists who make up the collection are by no stretch of the imagination uncritical, they are even distinctly aggressive. But they all have a different voice; they are individual and subjective. The artists represent a wide variety of ideas. They also represent a wide variety of countries, or geographical points of view. Unproblematical is not a description one could apply to them. Superficiality as a comfortable kind of carelessness is certainly not their métier.

The authors of the Hess Collection ask their questions on behalf of us all. They may believe in an ideal construction of the world, like the Zurich group of Concrete Artists. Their explorations of reality may be expressive in nature, like the artists of Central Europe. They may risk assumptions that appear to be beyond the range of human logic. Artists value the heart as well as the head. The soul of a work of art fluctuates between reason and emotion. We have here artists who get their ideas down very fast, and artists who are slow and deliberate and think everything through very carefully. A gesture can convey the same message as a theoretical construct. But they all believe in their own ideas.

European artists, no doubt, under the influence of the Hegelian and Cartesian tradition, are more in-

clined towards theory than the pragmatic Americans. The American work of art is more constitutive than the European, which is often marked by the pallor of thought. The European asks why, wherefore, to what end? The American says, "Let's do it". Go West, Artist.

Different temperaments reveal themselves. But they are important if we are to understand today's – or rather, tomorrow's world.

Common to both continents is the way art projects itself into the future. The artist takes the here and now as his starting point, but he is also asking what will it be like tomorrow.

A visit to the Hess Collection is thus often like a game of "detectives". Except that no judgment is passed as to what is good and what is bad. The artist is completely free in what he does. He is responsible to himself; he pinpoints his own questions. He offers unexpected answers. He hates norms, because it is his business to seek new ones. The viewer is invited to enter into a dialogue, even if this is not easy at first.

But besides the many stylistic categories established by art history, the viewer who asks direct questions and is prepared to take a long time over asking them, will find answers that are relevant to his own existence.

This is as true of the construct as it is of the "War Games", those direct, thematic, iconographic statements. The abstract, the non-representational discovers things in common with the representational.

Photorealism is there, as is the object artist. The sensualist and the intellectualist alike.

Art after 1945 is no longer system-inherent. On the contrary, it is almost aggressively opposed to everything that constitutes the norms of society. Art is its own convention. It is an adventure, a new departure.

The visitor must therefore be prepared to share the preferences of the collector. And he should not forget that a private individual is making something public here that was once private and very personal to himself. Private collections are in a better position than public museums to pose essential questions of principle. The pure love of art tends to hide behind this. The origin of this love is the fact that art is itself a declaration of love made to the viewer. A declaration of love for the simple reason that the artist lays bare his own problems without inhibition and without playing hide-and-seek. The work of art is a vehicle for the individual to ask questions in public. This makes the work of art a manifesto. Every single artefact in the Hess Collection possesses this criterion of quality. When things are difficult and disturbing, that's when they become interesting.

The pluralism of the collection has its origin in precisely this point of view – which is legitimate by virtue of the fact that it corresponds to the basic principles of art over the last few decades. Take action, re-form, transform – in order to focus attention on something.

Contemporary art is always disturbing, and good art will continue to be so. But if we are to understand the world, then we certainly need the art of our own time. It alone is capable today of bringing to our awareness the knowledge that is essential if our understanding of the world is to be more than just purpose-orientated. Art is one of the last derivatives of human nature. An individual can choose to do something that has no immediate practical application. Art is free, is not determined by dictatorships, not shaped by parliamentary bills.

That is why art is often incomprehensible and at times seriously provoking; but it is also why art has rooted in it that character which enables it to make meaningful statements.

Let us think for a moment about art. Does it only exist as an ornament for our world, simply to make it more beautiful? What is it, precisely, that we expect of art? Should it affirm? Or should it call in question? The Hess Collection opts for the latter. It is eager to experiment, loves what is different, loves to question, to scrutinize. It is alive with curiosity, projects itself naturally into the future, is absolutely predestinated for what is new. Since all of us experiment in life, the Hess Collection is exemplary.

Let me attempt a historical comparison. The French philosopher Blaise Pascal compared our knowledge with a circle. The greater the radius, the greater the points of contact with the unknown. In other words, the greater the circle in which we move, the more likely we are to enter areas that are unfamiliar to us. Artists work in this tangential area of our aesthetic knowledge. This is where their true place and their responsibility lie. Their individual interests expand the consciousness of us all.

Art is not beautiful because it affirms us in what we are. But it is relevant because it presents a challenge to us. If we still have dreams, then we need art, because its answers are so seldom pedictable.

The catalogue gives a short biography of each artist and an authenticated quotation in which we hear the voice of the artist himself. Not all the artists speak about their work; there are those who deliberately avoid words. The quotations here are intended as an aid to the understanding of the works. They make specific statements about the artist's attitude to art and about his view of the world. The infinitely wide variety of ways of thinking and modes of expression brings powerfully home to us what riches the human mind and hand have it in their power to create. Art is a declaration of love from the artist to every one of us in the world.

Magdalena Abakanowicz

Abakanowicz, Magdalena
Born 1930 in Falenty, Poland
Lives and works in Warsaw

Studied at the Academy of Fine Arts in Warsaw, graduating in 1954.

She won international acclaim with her monumental, three-dimensional woven forms called "Abakans". Later she turned to figurative, metaphorical sculptures, using first burlap, then wood, metal, clay and stone. She also draws and paints.

Particularly characteristic are her large cycles of mutating forms, similar in general shapes but differing in the detail.

She travels extensively with her one-person-exhibitions, which she arranges herself as spaces for contemplation and which bring her into contact with people.

Pursuing similar aims, she also creates in the landscape permanent "spaces" out of large groups of sculptures.

1 • Standing Figure I. 1983/86. Bronze. 61:20:11⅜ inches, 155:51:29 cm.
2 • Standing Figure II. 1983/86. Bronze. 63:19⅝:11⅜ inches, 160:50:29 cm.
3 • Standing Figure III. 1983/86. Bronze. 62½:18⅛:11⅜ inches, 159:46:29 cm.
4 • From the Cycle 'Anonymous Portraits': Face I. 1986. Bronze. 25½:8:9 inches, 65:20.5:23 cm.
5 • From the Cycle 'Anonymous Portraits': Face II. 1986. Bronze. 27⅜:10:8¼ inches, 69.5:25.5:21 cm.
6 • From the Cycle 'Anonymous Portraits': Face IV. 1986. Bronze. 24¾:7½:8½ inches, 63:19:21.7 cm.
7 From the Cycle 'Anonymous Portraits': Face VIII. 1986. Bronze. 25¼:7½:10⅜ inches, 64:19:26.3 cm.
8 • From the Cycle 'Anonymous Portraits': Face IX. 1986. Bronze. 26:8⅞:8⅜ inches, 66:25:21.2 cm.
9 • From the Cycle 'Incarnations': MAGDEBIK. 1986/87. Bronze. 25:8:9 inches, 63.5:20.5:23 cm.
10 • From the Cycle 'Incarnations': MAPA. 1986/87. Bronze. 25¾:8⅝:7½ inches, 64.5:22:19 cm.
11 • From the Cycle 'Incarnations': MAGDIKA. 1986/87. Bronze. 25:10⅜:7½ inches, 63.5:26.5:19 cm.
12 • From the Cycle 'Incarnations': MAGDEBAC. 1986/87. Bronze. 24½:7½:8⅝ inches, 62.5:19:22 cm.
13 • Crowd. 1986/87. Burlap, resin. 19 figures, each 67:20⅞:15¾ inches, 170:53:40 cm
14 • From the Cycle 'War Games': Zadra. 1987/88. Oakwood, burlap, resin, iron. 4¼:3¼:27⅞ ft., 130:100:835 cm.

• illustration in this catalogue

"I once observed mosquitoes swarming. In gray masses. Host upon host.

Little creatures in a slew of other little creatures. In incessant motion.

Each preoccupied with its own spoor. Each different, distinct in details of shape. A horde emitting a common sound.

Were they mosquitoes or people?"

"I feel overawed by quantity where counting no longer makes sense. By unrepeatability within such a quantity. By creatures of nature gathered in herds, droves, species in which each individual while subservient to the mass retains some distinguishing features.

A crowd of people or birds, insects or leaves is a mysterious assemblage of variants of certain prototype. A riddle of nature's abhorrence of exact repetition or inability to produce it. Just as a human hand cannot repeat its own gesture.

I invoke this disturbing law, switching my own immobile herds into that rhythm."

M. A., from the catalogue:
Expressiv, Central European Art since 1960,
Vienna–Washington 1987/88

1
Standing Figure I. 1983/86
Bronze
61:20:11⅜ inches

2
Standing Figure II. 1983/86
Bronze
63:19⅝:11⅜ inches

3
Standing Figure III. 1983/86
Bronze
62½:18⅛:11⅜ inches

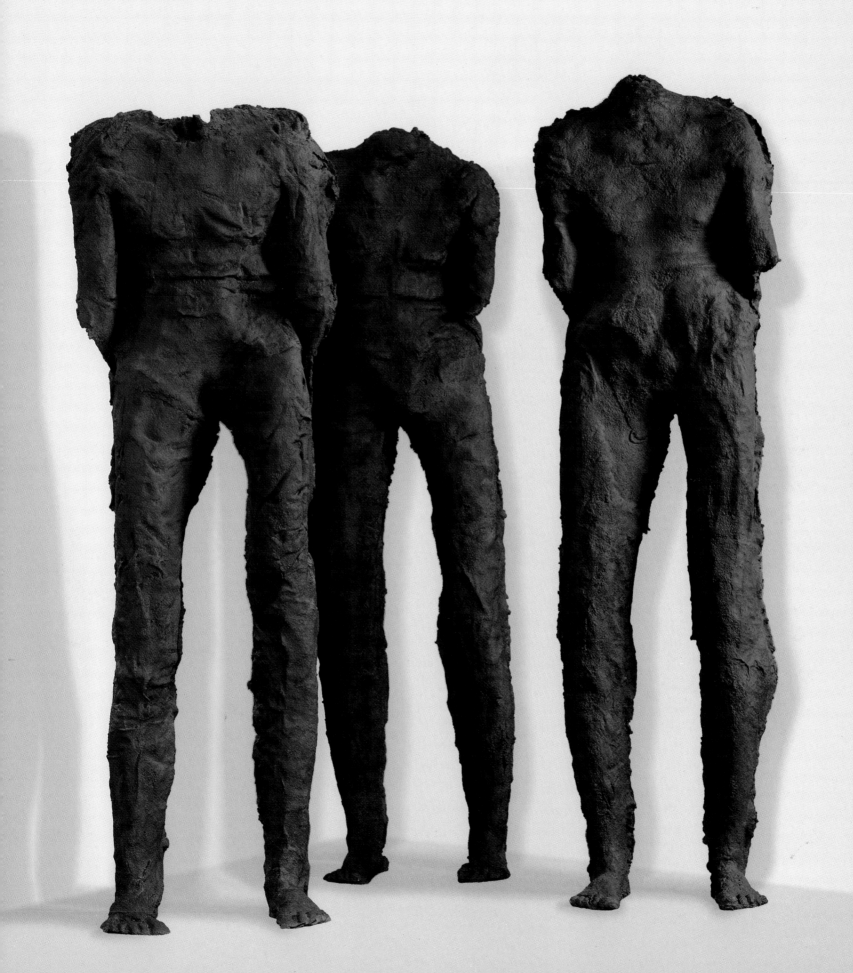

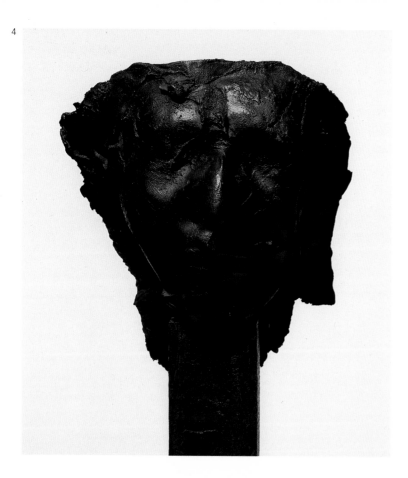

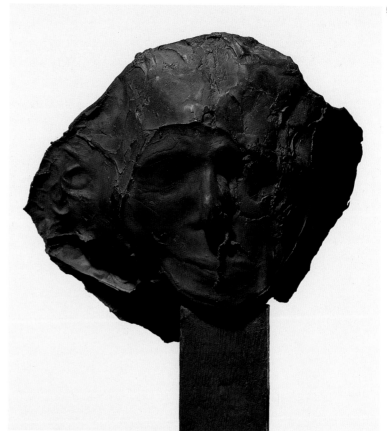

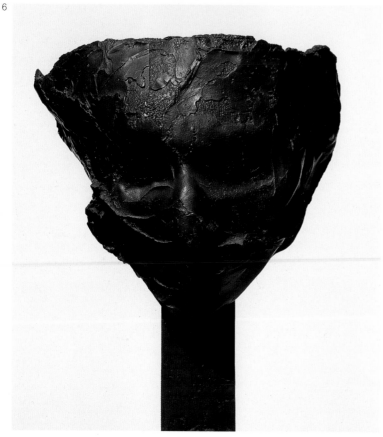

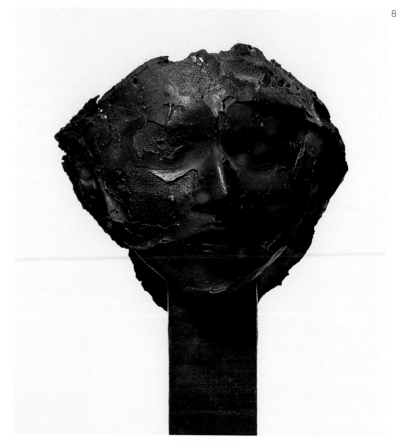

From the Cycle 'Anonymous Portraits':
4 Face I. 1986. Bronze. 25½ : 8 : 9 inches
6 Face IV. 1986. Bronze. 24¾ : 7½ : 8½ inches

5 Face II. 1986. Bronze. 27⅜ : 10 : 8¼ inches
8 Face IX. 1986. Bronze. 26 : 8⅞ : 8⅜ inches

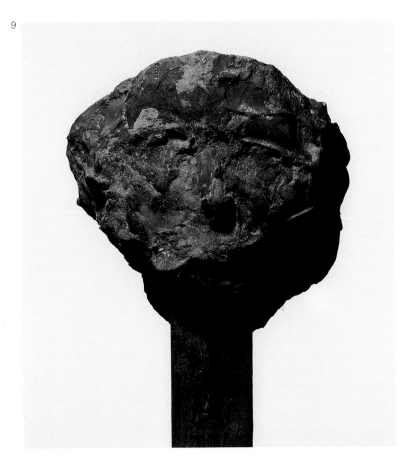

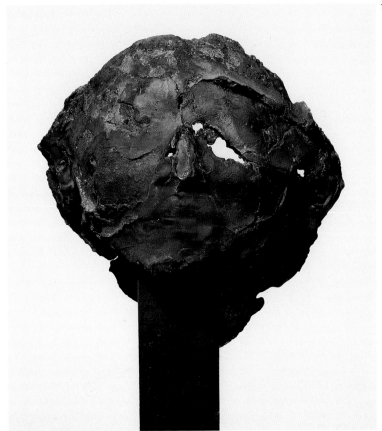

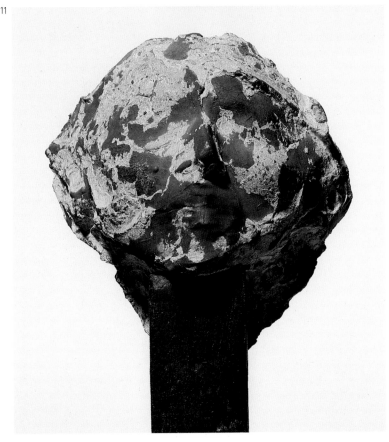

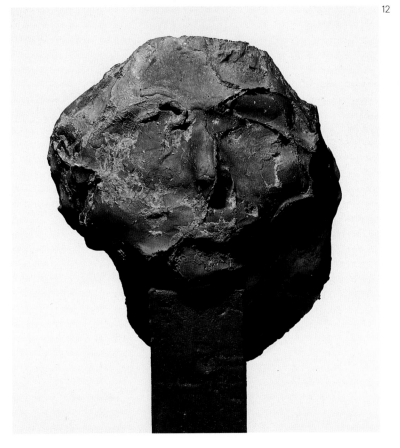

From the Cycle 'Incarnations':
9 MAGDEBIK. 1986/87. Bronze. 25:8:9 inches
11 MAGDIKA. 1986/87. Bronze. 25:10⅜:7½ inches

10 MAPA. 1986/87. Bronze. 25¾:8⅝:7½ inches **Abakanowicz**
12 MAGDEBAC. 1986/87. Bronze. 24½:7½:8⅝ inches

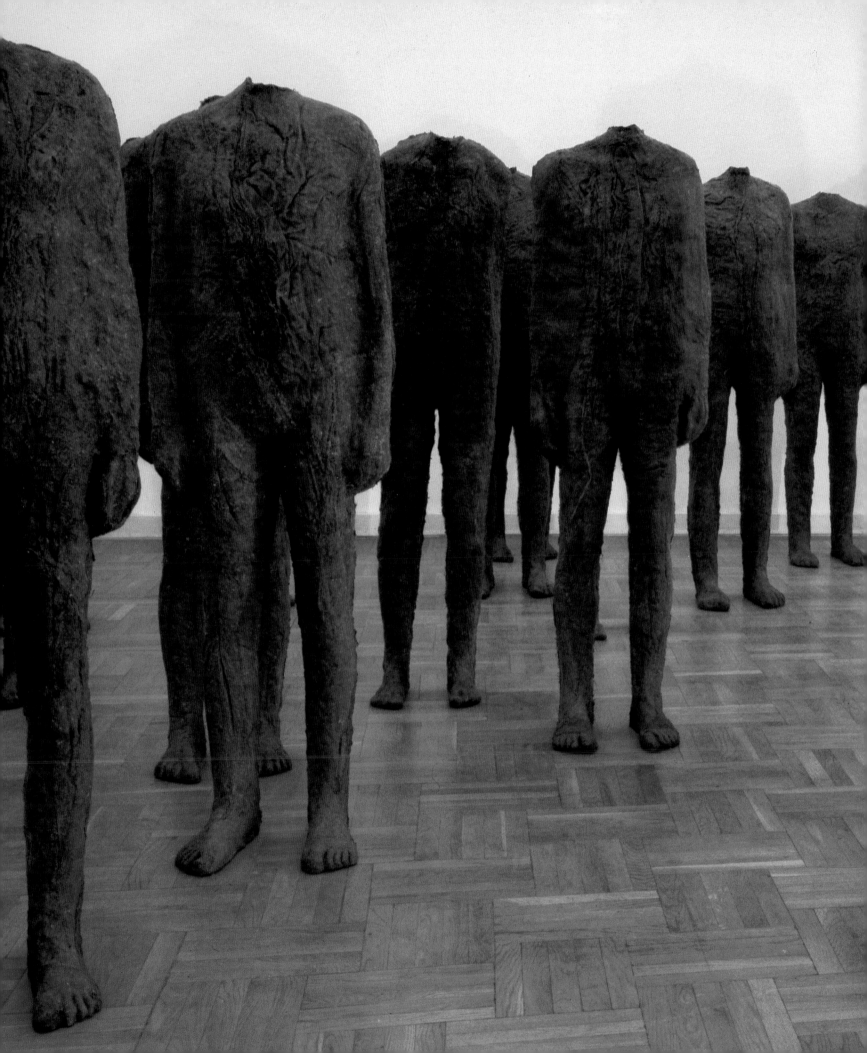

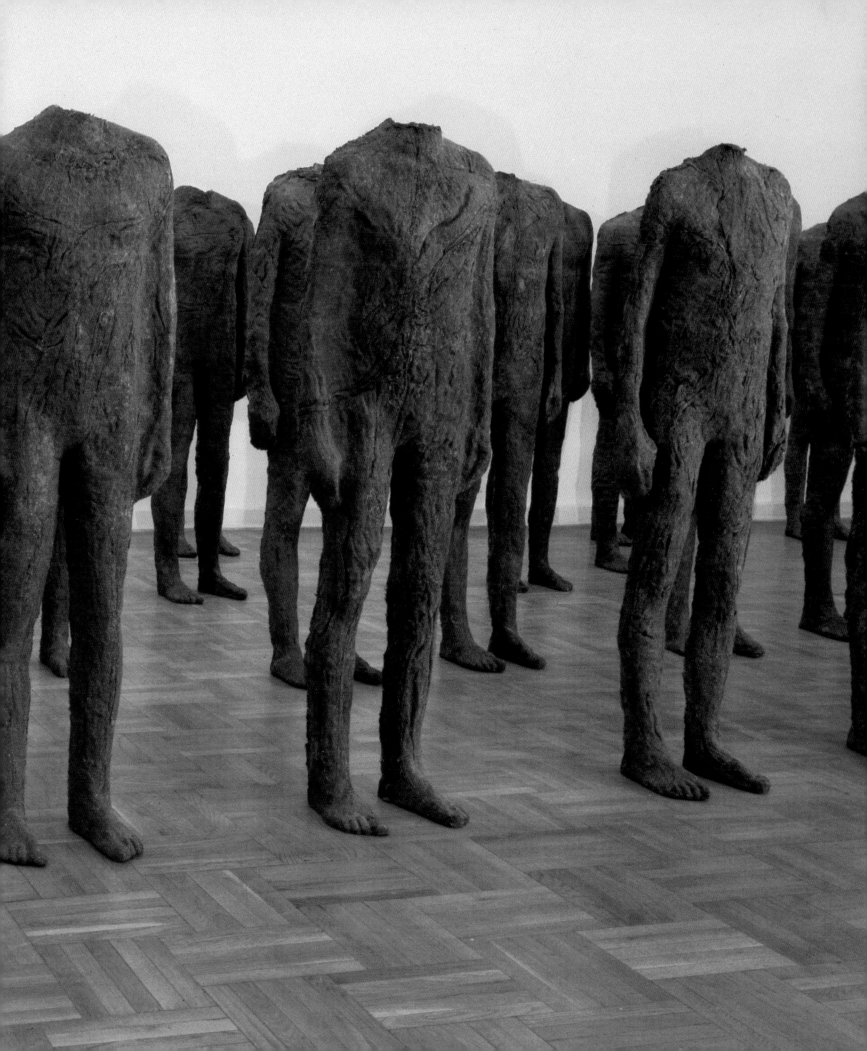

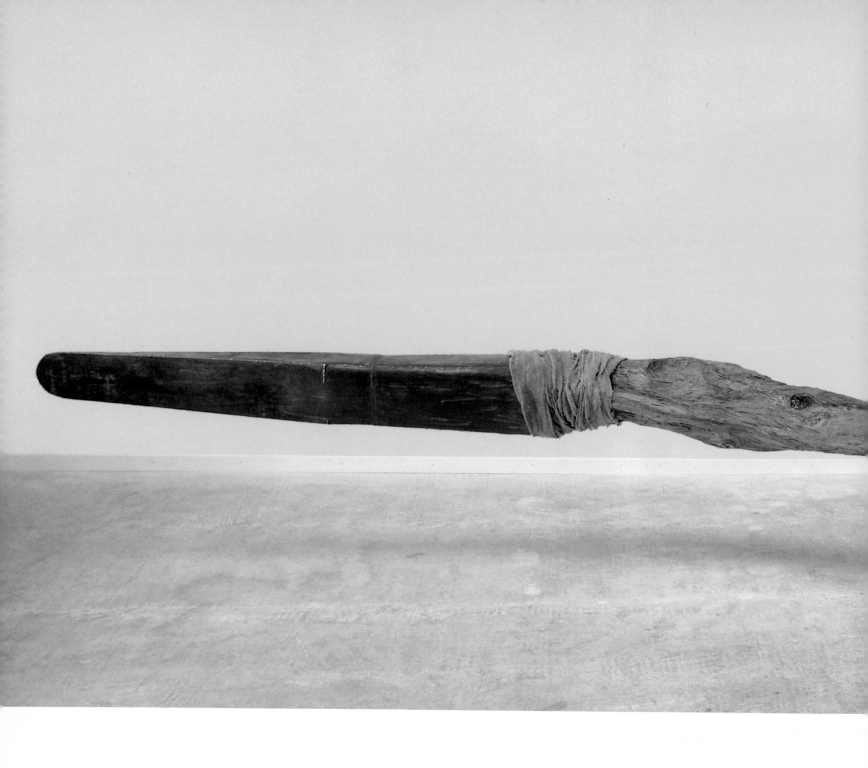

◁ 13 Crowd. 1986/87. Burlap, resin. 19 figures, each 67 : 20⅞ : 15¾ inches

Abakanowicz

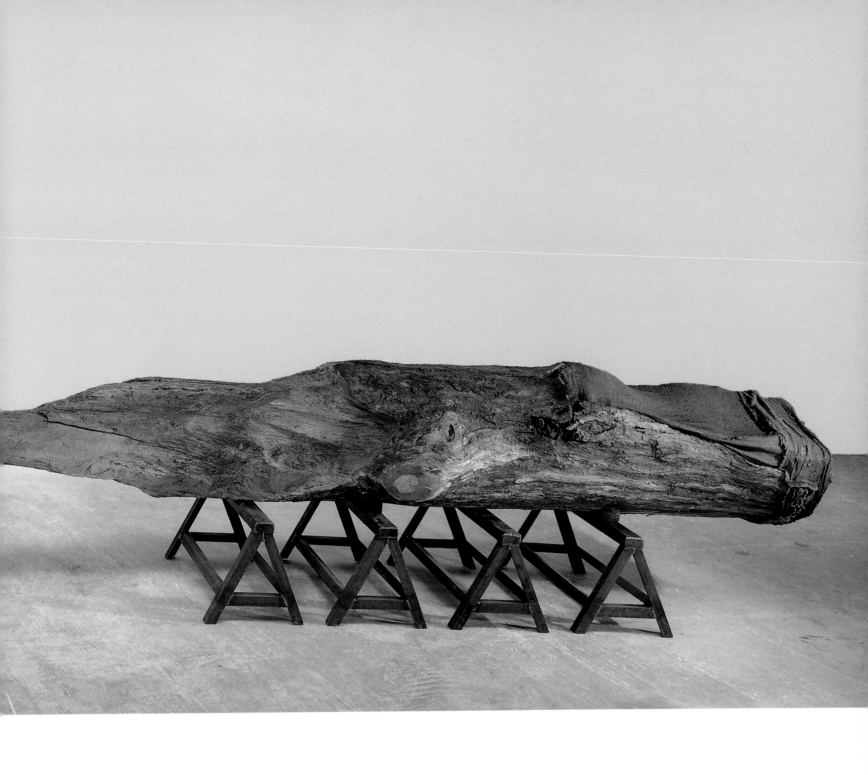

14 From the Cycle 'War Games': Zadra. 1987/88. Oakwood, burlap, resin, iron. 4¼ : 3¼ : 27⅜ feet

Abakanowicz

Armando

Armando

Born 1929 in Amsterdam, Holland
Lives and works in Berlin

Started his "Peintures Criminelles" in 1954, "Paysages Criminels" in 1955, "Espaces Criminels" in 1956; founder member in 1958 of the Nederlandse informele groep; 1979/80 held an Artists-in-Berlin scholarship from the German Academic Exchange Programme (DAAD).

The Dutchman paints, draws, sculpts and writes poetry.

"Here I am.
This is my voice.
After eternities this all comes through
Because I am so impetuous,
So full of abandon.
Who will I be?
Ah, that is still unknown ..."

15 • J'ai tué mon frère Abel, 8/54. 1954. Oil on hardboard. 51½:48¼ inches, 131:122.5 cm.
16 • Der Feind unterwegs. 1978/79. Diptych. Oil on canvas. each 70⅞:45¼ inches, 180:115 cm.
17 • Der Baum. 1984. Oil on canvas. 94½:43¼ inches, 240:110 cm.
18 • Fahne. 1985. Oil on canvas. 65:88½ inches, 165:225 cm.
19 • Melancholie. 1986. Oil on canvas. 78:78 inches, 198:198 cm.
20 • Das Tor 9.7.87. 1987. Oil on canvas. 78:78 inches, 198:198 cm.
21 • Gestalt 18.5.88. 1988. Oil on canvas. 78:78 inches, 198:198 cm.

22 • Fahne 2. 1988. Bronze 1/5. 79¼:33:20⅝ inches, 201:84:52.5 cm.

23 Gefechtsfeld. 1987. Oil on cardboard. 20:28¾ inches, 51:73 cm.
24 Gefechtsfeld. 1987. Oil on cardboard. 20:28¾ inches, 51:73 cm.
25 Der Baum. 1988. Oil on cardboard. 20:28¾ inches, 51:73 cm.

26 Landschaft. 1957. Pencil on paper. 19⅝:25½ inches, 50:65 cm.
27 • Untitled. 1959. Pencil on paper. 30¾:45¼ inches, 78:115 cm.
28 • Untitled. 1967. Pencil on paper. 30¾:45¼ inches, 78:115 cm.
29 • Untitled. 1975. Pencil on paper. 39⅜:29½ inches, 100:75 cm.
30 Fahne. 1981. Black chalk on paper. 7:5¼ inches, 18:13 cm.
31 Fahne. 1981. Pencil on paper. 7:5¼ inches, 18:13 cm.
32 Landschaft. 1982. Pencil, collage on paper. 28⅜:19¼ inches, 72:49 cm.

• illustration in this catalogue

A., from the catalogue: Armando,
Hamburg 1985

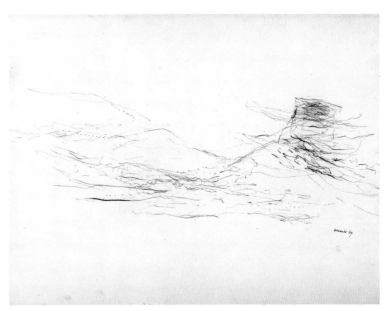

27
Untitled. 1959
Pencil on paper
30¾ : 45¼ inches

28
Untitled. 1967
Pencil on paper
30¾ : 45¼ inches

29
Untitled. 1975
Pencil on paper
39⅜ : 29½ inches

Armando

15
J´ai tué mon frère Abel. 8/54. 1954
Oil on hardboard
51½ : 48¼ inches

Armando

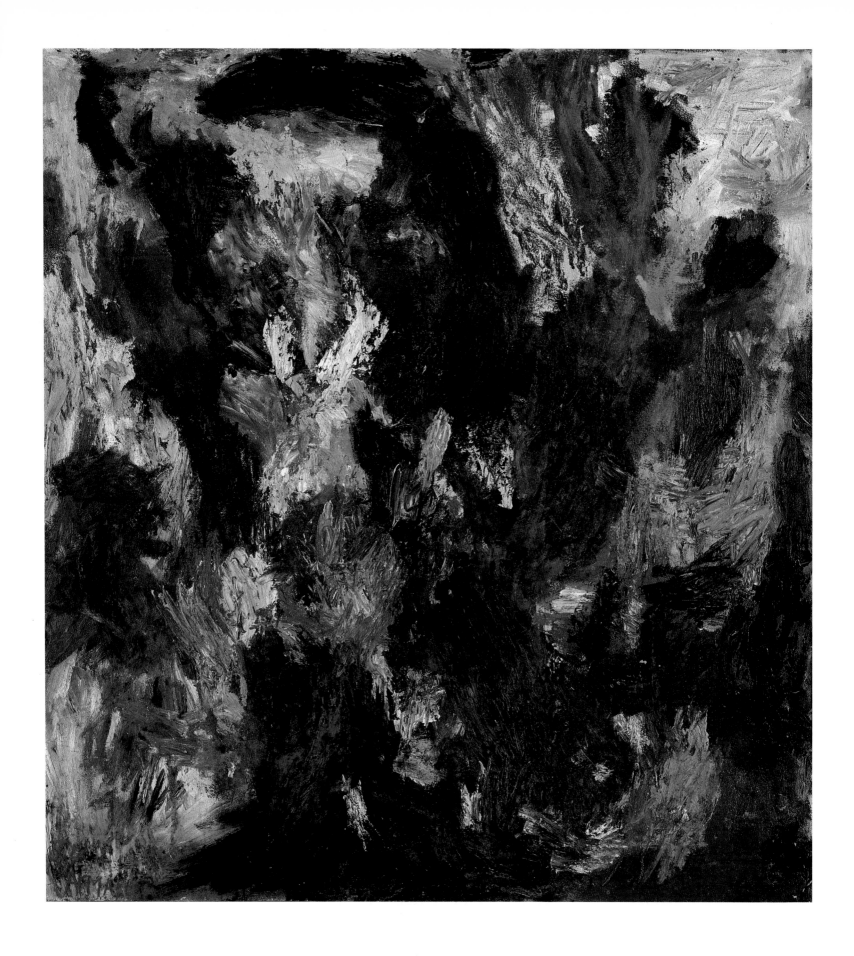

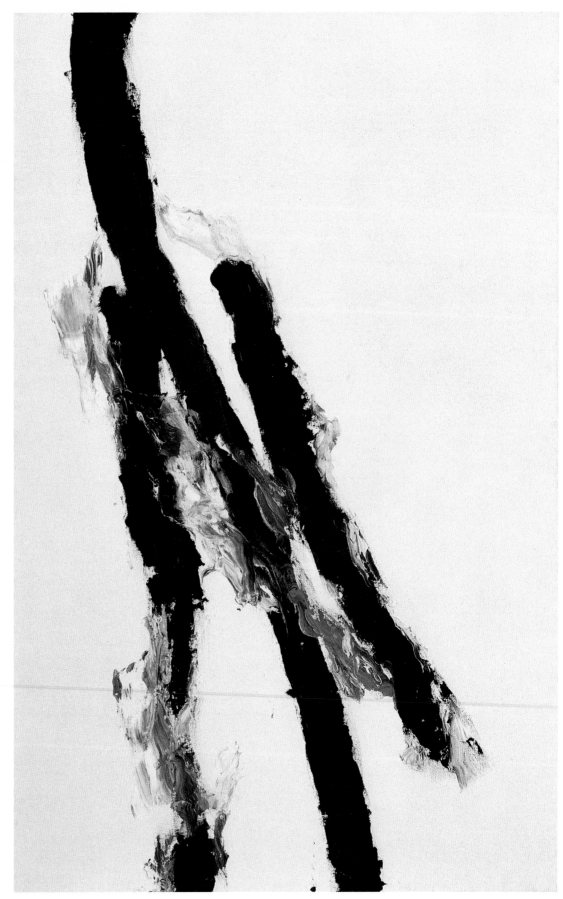

16
Der Feind unterwegs. 1978/79. Diptych.
Oil on canvas
Each 70⅞ : 45¼ inches

Armando

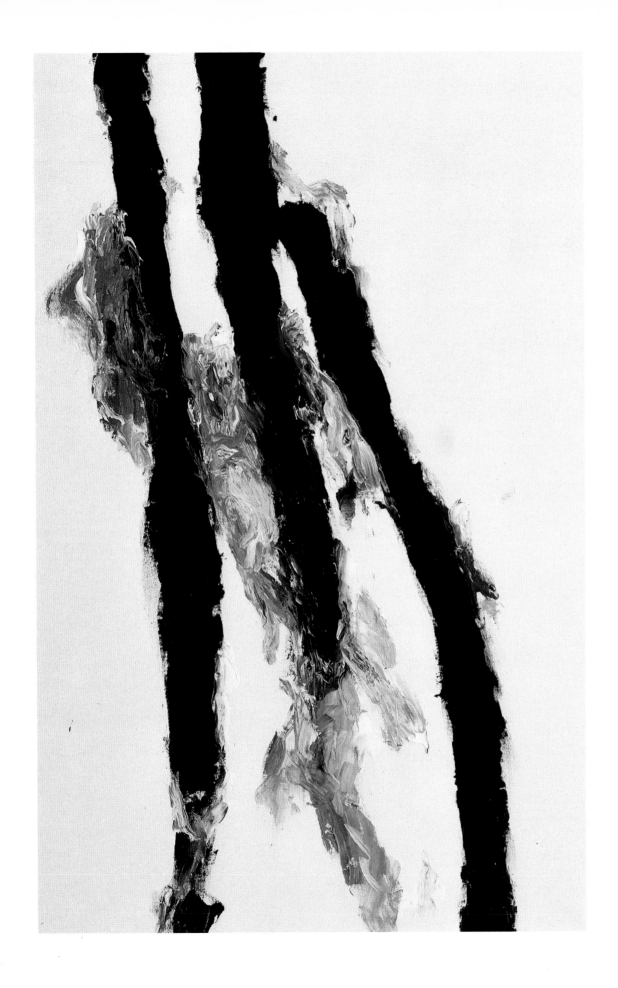

Armando

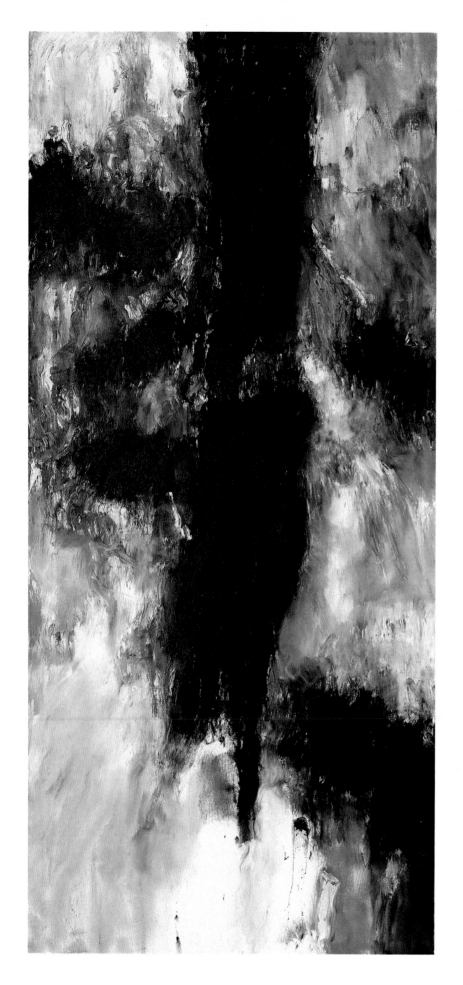

17
Der Baum. 1984
Oil on canvas
94½ : 43¼ inches

Armando

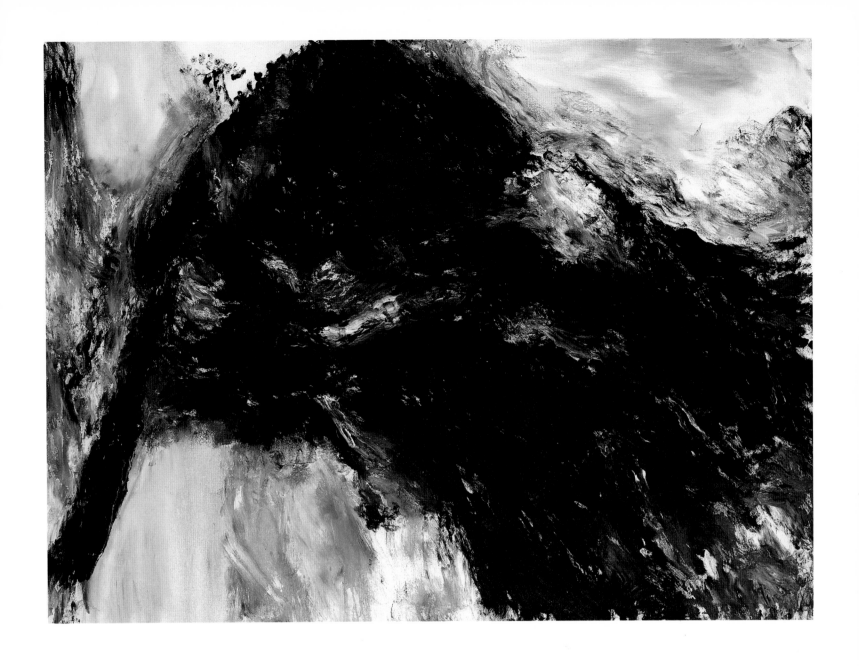

18 Fahne. 1985. Oil on canvas. 65 : 88½ inches

Armando

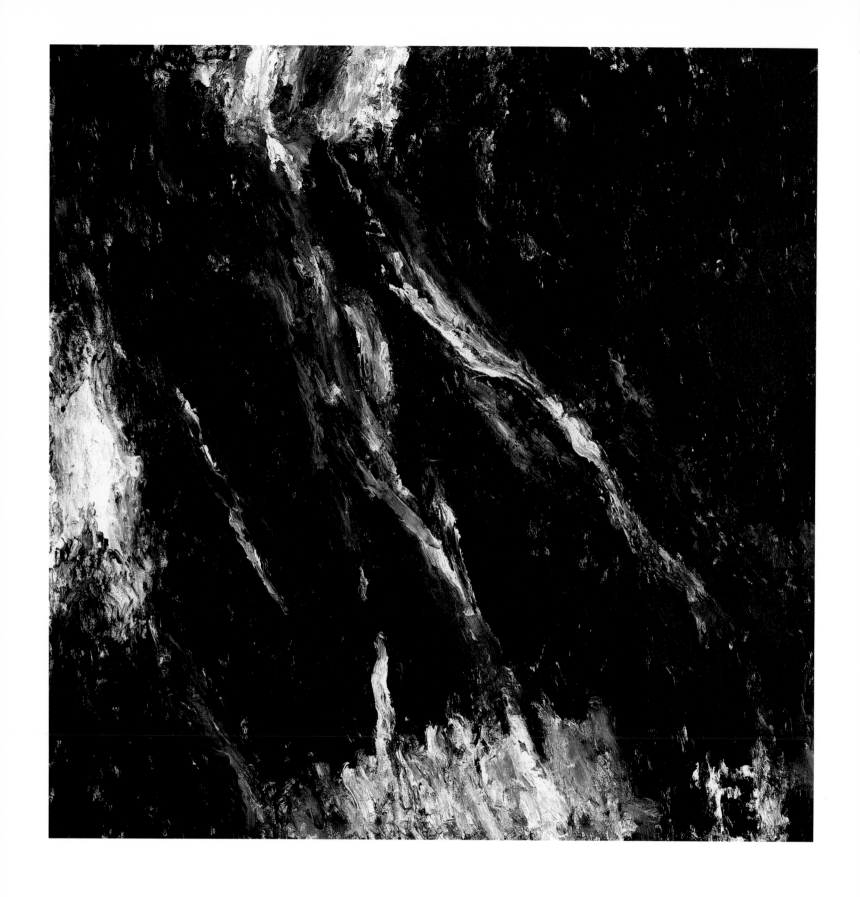

19 Melancholie. 1986. Oil on canvas. 78:78 inches

Armando

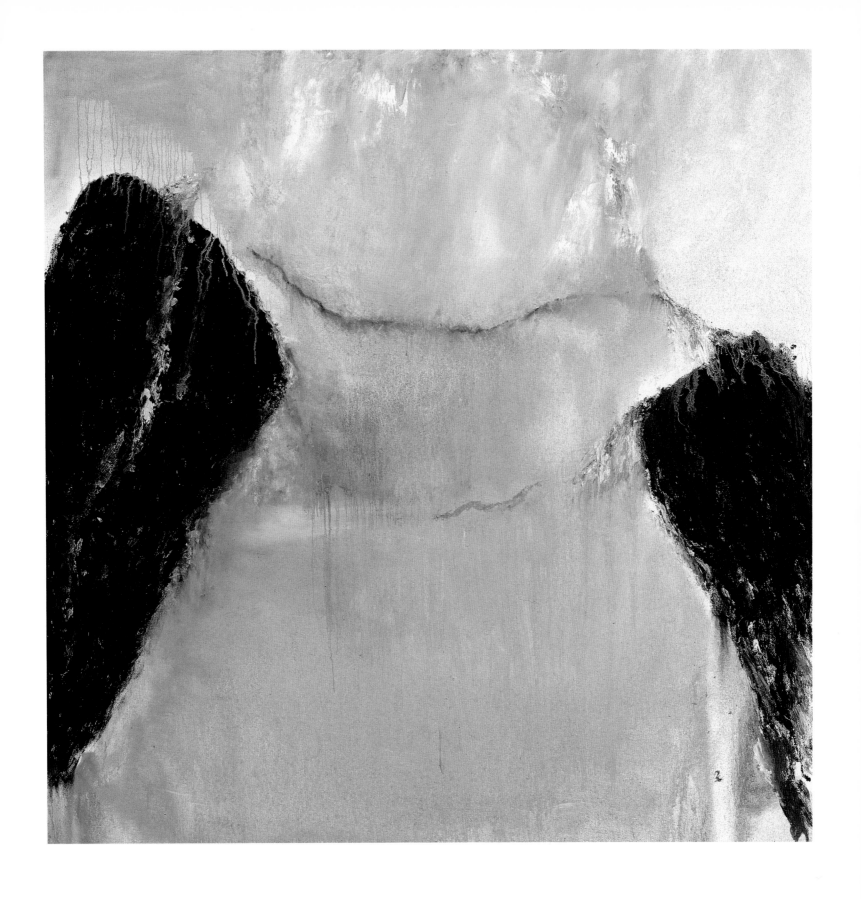

20 Das Tor 9.7.87. 1987. Oil on canvas. 78:78 inches

Armando

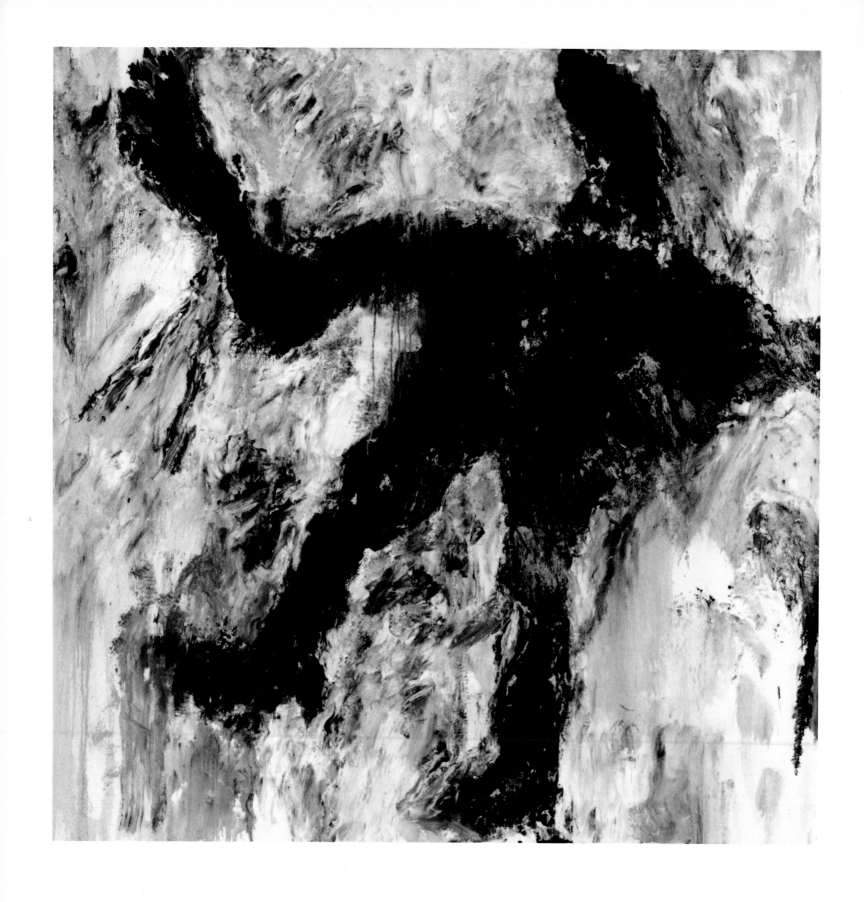

21 Gestalt 18.5.88. 1988. Oil on canvas. 78:78 inches

Armando

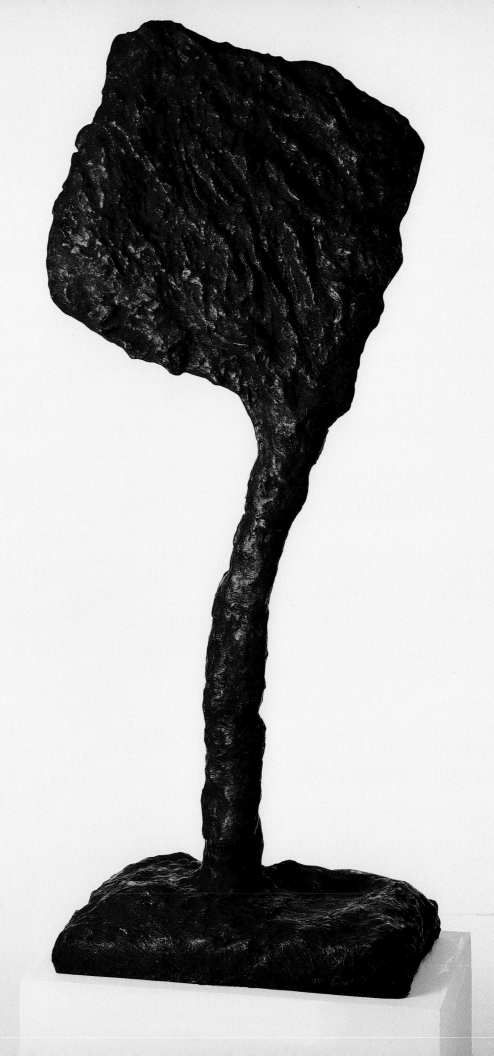

22
Fahne 2. 1988
Bronze 1/5
79¼ : 33 : 20⅝ inches

Armando

Francis Bacon

Bacon, Francis
Born 1909 in Dublin of English parents
Lives and works in London

Self-taught in painting; after spending some time in Germany and France he settled in London in the late Twenties; designed furniture and interior decoration; took up painting again after 1945.

The British painter is a lone wolf. The psychologizing realism of his human figures has nothing to do with portraiture. What he wants to show are situations of extremity, metamorphoses of human existence, other possibilities of being.

"You simply can't bring off a portrait today. You're asking chance to fall your way *all the time*. The paint has to slide into appearance at every level, the accidents have to be all in your favour."

F. B., from John Russell, Francis Bacon, London 1971

33 • Study for a Portrait. 1953. Oil on canvas. 78 : 54 inches, 197 : 137 cm.
34 • Study of Man Talking. 1981. Oil on canvas. 78 : 58 inches, 198 : 147.5 cm.

• illustration in this catalogue

33
Study for a Portrait. 1953
Oil on canvas
78 : 54 inches

Bacon

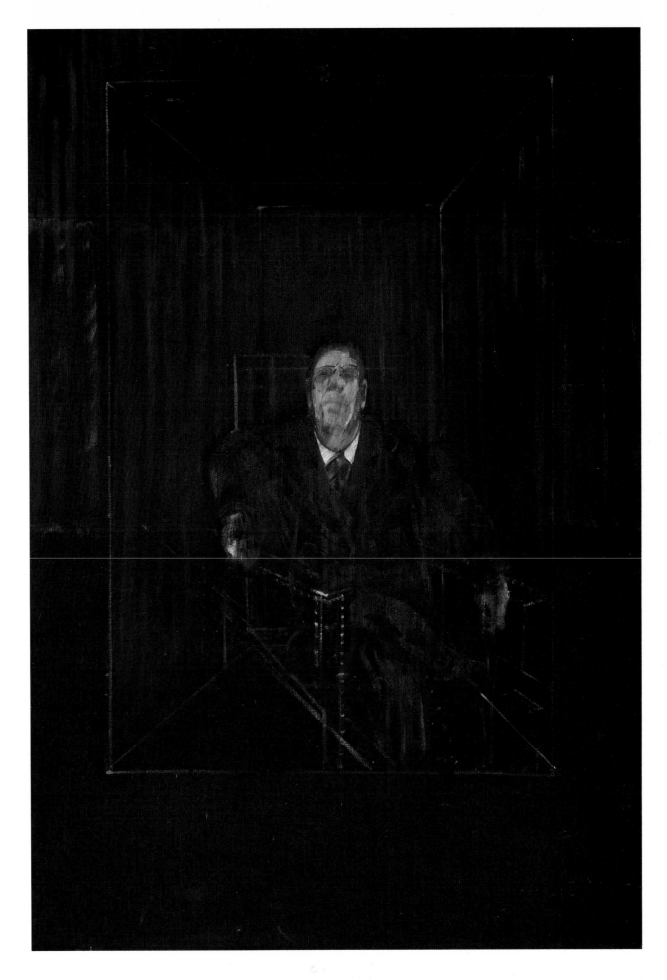

34
Study of Man Talking. 1981
Oil on canvas
78:58 inches

Bacon

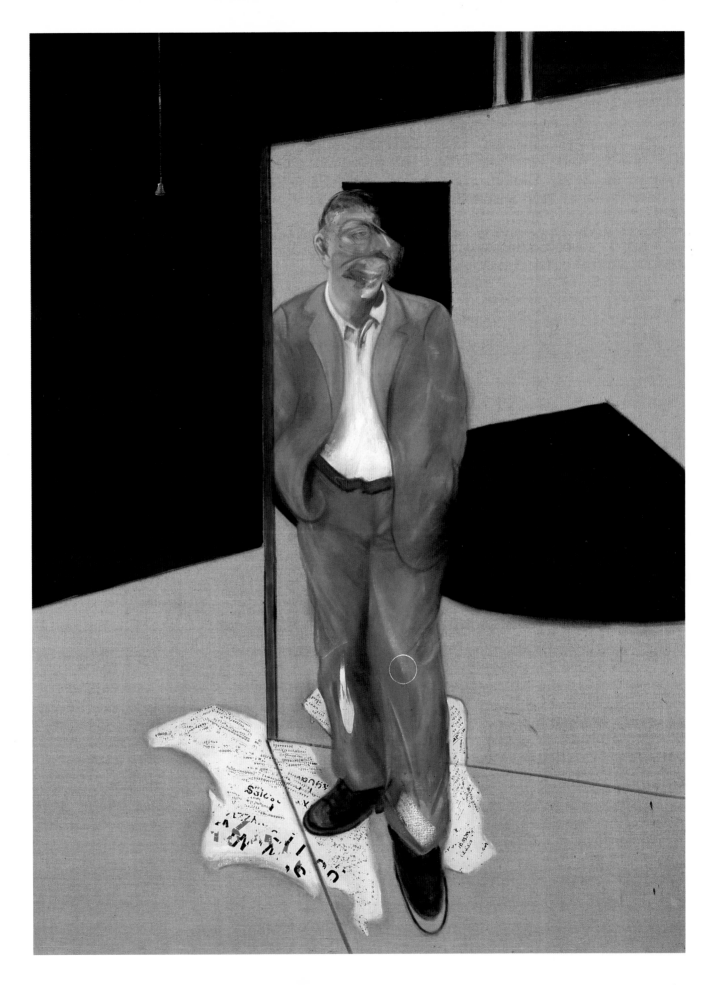

Georg Baselitz

Baselitz, Georg

Born 1938 in Deutschbaselitz in Saxony, Germany
Lives and works in Derneburg in Lower Saxony

1956 entered the Academy of Visual and Applied Arts in East Berlin and in 1958 took the name of Baselitz; 1957–64 was a student at the Academy of Visual Arts in West Berlin; 1965 awarded a scholarship to the Villa Romana in Florence, 1971–73 Forst and Mussbach an der Weinstrasse, 1975 moved to Derneburg; 1978 appointed professor in Karlsruhe; since 1983 professor at the Academy of Arts in Berlin.

The West German artist is a painter, draughtsman, sculptor and graphic artist in the expressive vein. He extends German Expressionism into a new artistic freedom, whereby the freedom takes precedence over the theme.

"Initially, the viewer plays no part in the relationship between the painter and the picture, because he can have no influence on the way the painting is coming along. The viewer in fact sees only results...

This isolation is not deliberately cultivated, it is something that just happens when one realizes at some point that one is working on something very specialized, something that no one else understands. The isolation is not a prerequisite, it is the result of a particular manner of working and thinking, which does not conform to normal requirements. Painters and musicians too, probably, do actually work within the context of contemporary life, but not in the sense of a communication to be relayed by the normal channels. It's a question rather of using the precise way in which one works and thinks to distance oneself from a communication that might be understood by everyone."

G. B., from the catalogue: Georg Baselitz, Bielefeld 1985

35 • Ein grosser Hund. 1967/68. Oil on canvas. 63¾:51¼ inches, 162:130 cm.
36 • Elke 1 – Derneburg. 1975. Oil on canvas. 63¾:51¼ inches, 162:130 cm.

37 • Flaschen – 5 Drawings. 1978. Pencil, charcoal and watercolor on paper. Each 23⅝:16½ inches, 60:42 cm.

• illustration in this catalogue

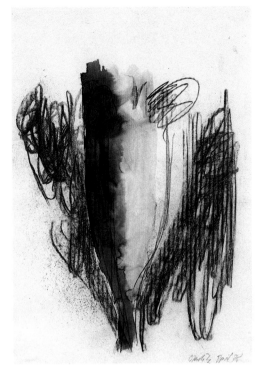

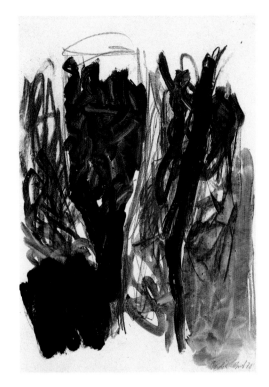

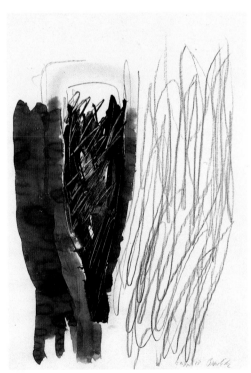

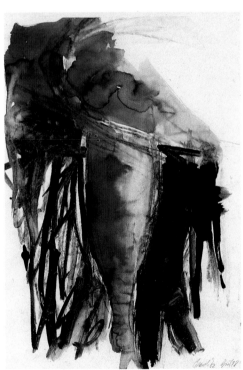

37 Flaschen – 5 Drawings. 1978. Pencil, charcoal and watercolor on paper. Each 23⅝ : 16½ inches

Baselitz

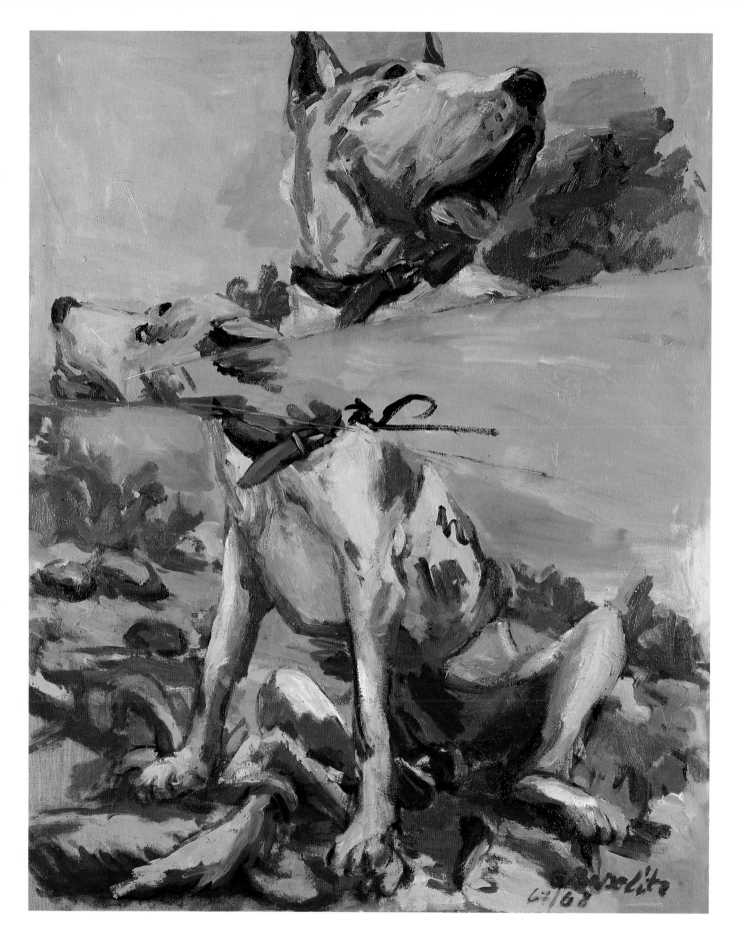

Baselitz

35 Ein grosser Hund. 1967/68. Oil on canvas. 63¾:51¼ inches

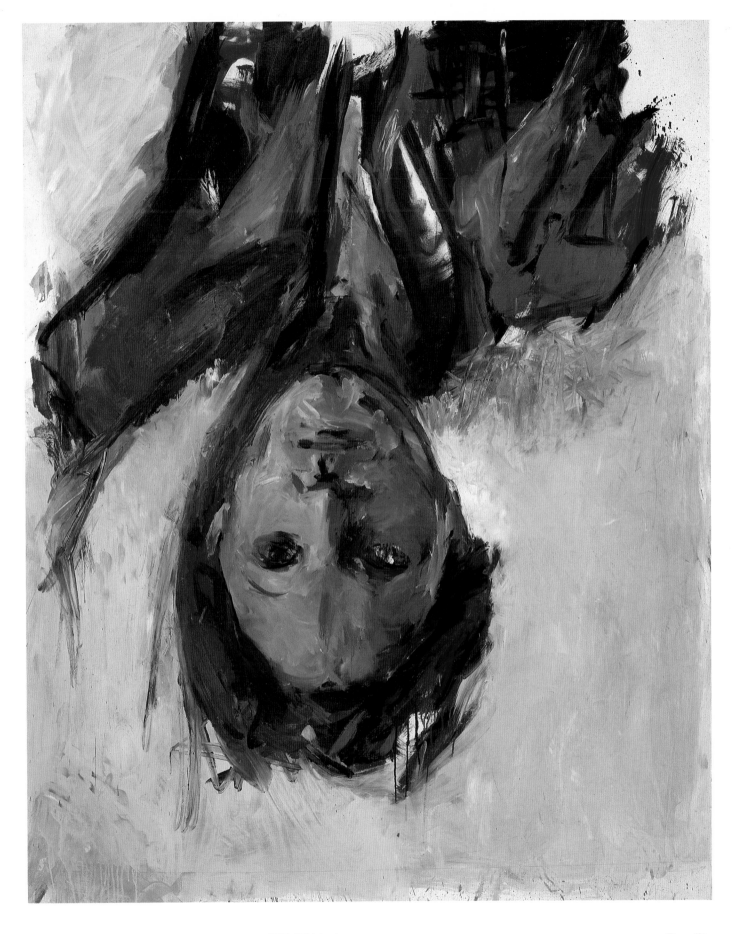

36 Elke 1 – Derneburg. 1975. Oil on canvas. 63¾ : 51¼ inches

Baselitz

Boyle Family

Boyle Family

Mark Boyle and Joan Hills
Born in Glasgow and Edinburgh, Scotland
Worked jointly as independent artists since 1957

Both mainly self-taught in art. Collaborated on light environments and theatrical events, 1960–65; directors Sensual Laboratory, London 1966; light shows for UFO Club, London 1967; light environments for music groups – Jimi Hendrix Experience and Soft Machine, UK and USA 1968–69; working on Earth pieces since 1964 and "Journey to the Surface of the Earth" since 1967. Have worked with their children Sebastian and Georgia for many years, using the collective name "Boyle Family" since 1985.

"You don't want any image, you want to be transparent, a projection almost seen on a cloud of cigarette smoke. And you know as you say it that all you're doing is to make another kind of image, perhaps more suited to your circumstances than any other. You're saying I am what I produce, I am a circuit of no importance. My anonymity is valuable to me.

You would like to have a bitter image of yourself. But you're not even bitter any longer. You have no ambitions. You've seen it all and you knew before you saw it that their Hilton Hotels and their Cadillacs were going to add up to precisely nothing. You're an onion, and to find the inner, essential onion you strip away the layers protecting the centre, to discover that at the centre there are only more layers and beyond them a smell and a blur of tears."

M.B., from the catalogue: Mark Boyle, Den Haag 1970

38 • Study of Draincover with Mud and Stones and Blue Paint Spills. 1985. Painted fiberglass. 4:4 ft., 122:122 cm.
39 • White Cliffs of Dover Study. 1987. Painted fiberglass. 6:12 ft., 182.5:362 cm.
40 • Lorry Park Study with Concrete Kerb. 1987. Painted fiberglass. 6:12 ft., 182.5:362 cm.

• illustration in this catalogue

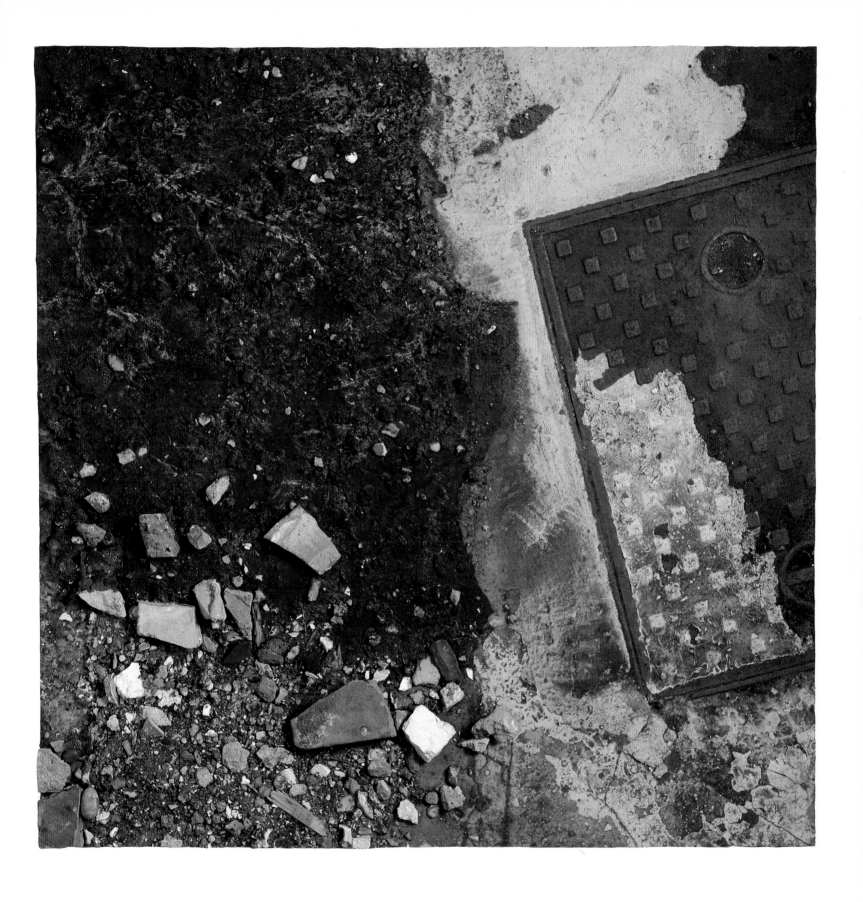

38 Study of Draincover with Mud and Stones and Blue Paint Spills. 1985. Painted fiberglass. 4:4 feet

Boyle Family

39
White Cliffs of Dover Study. 1987
Painted fiberglass.
6:12 feet

Boyle Family

40
Lorry Park Study with Concrete Kerb. 1987
Painted fiberglass.
6:12 feet

Boyle Family

Franz Gertsch

Gertsch, Franz
Born 1930 in Mörigen, Switzerland
Lives and works in Rüschegg-Heubach near Bern

Franz Gertsch surprised everyone at documenta 5 in 1972 in Kassel by his new realism.

Painter and wood engraver.

The Swiss painter is a European realist, who approaches the problem of realism with the help of photography, opting for a heightened sublimation in the medium of paint. The wood engravings are paintings in another medium.

41 • Vietnam. 1970. Acrylic on unprimed half-linen. 80¾:114⅛ inches, 205:290 cm.
42 • Luciano II. 1976. Acrylic on unprimed cotton. 92¼:136¼ inches, 234:346 cm.
43 • Verena. 1982. Acrylic on unprimed cotton. 86⅝:126 inches, 220:320 cm.
44 • Johanna II. 1986. Tempera on unprimed cotton. 129⅞:114¼ inches, 330:290 cm.

45 • Irène IX. 1982. Watercolor on paper. 17:23⅛ inches, 43.2:58.9 cm.
46 • Irène XI. 1982. Watercolor on paper. 15½:22¾ inches, 39.5:57.5 cm.

47 Natascha 2, VI 2/5. 1986. Woodcut on yellow Japanese paper (in 3 plates).
Papersize: 45⅞:37¼ inches, 116.5:94.5 cm.
Printsize: 41¼:35½ inches, 105:90.4 cm.
48 Natascha 3, Braun-blau-grüne Serie I 4/4. 1986. Woodcut on yellow Japanese paper (in 3 plates).
Papersize: 45⅞:37¼ inches, 116.5:94.5 cm.
Printsize: 41¼:35½ inches, 105:90.4 cm.
49 Natascha 1, Türkis-Reihe II 1/6. 1987. Woodcut on yellow Japanese paper (in 3 plates).
Papersize: 45⅞:37¼ inches, 116.5:94.5 cm.
Printsize: 41¼:35½ inches, 105:90.4 cm.
50 • Grosser Holzschnitt 'Natascha', Blaue Reihe 15/18. 1988.
Woodcut on yellow Japanese paper.
Papersize: 107½:83½ inches, 273:212 cm.
Printsize: 91¼:72 inches, 232:183 cm.

• illustration in this catalogue

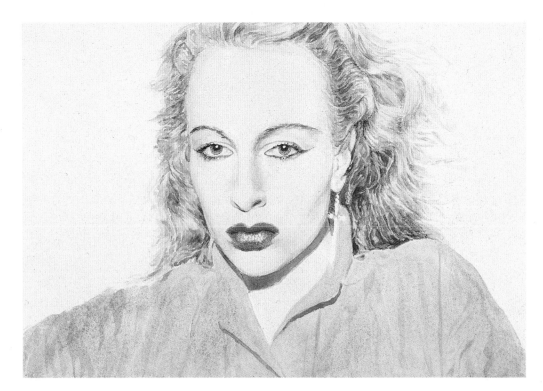

46
Irène XI. 1982
Watercolor on paper
15½ : 22¾ inches

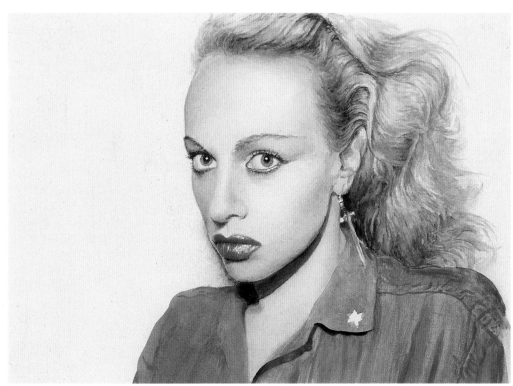

45
Irène IX. 1982
Watercolor on paper
17 : 23⅛ inches

Gertsch

41
Vietnam. 1970
Acrylic on unprimed half-linen
80¾ : 114⅛ inches

Gertsch

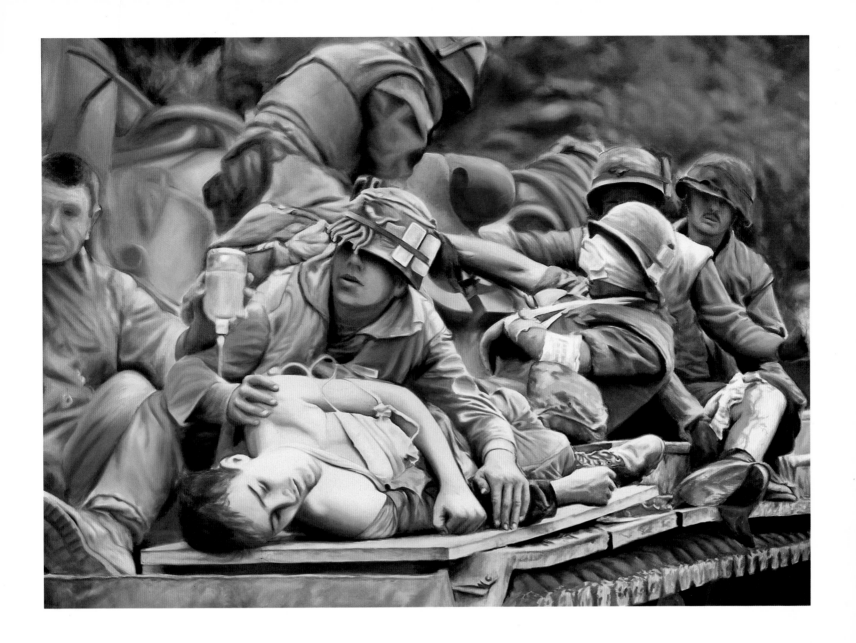

42
Luciano II. 1976
Acrylic on unprimed cotton
92¼ : 136¼ inches

Gertsch

43
Verena. 1982
Acrylic on unprimed cotton
86⅝ : 126 inches

Gertsch

44
Johanna II. 1986
Tempera on unprimed cotton
129⅞ : 114¼ inches

Gertsch

50
Grosser Holzschnitt 'Natascha'
Blaue Reihe 15/18
1988
Woodcut on yellow Japanese paper
Papersize: 107½:83½ inches
Printsize: 91¼:72 inches

Gertsch

Gilbert & George

Gilbert & George

Gilbert: born 1943 in the Dolomites, Italy
George: born 1942 in Devon, England
They live in London

1967 studied together at the St. Martin's School of Art in London.

The two artists work together. They create live art in performance, the photographs of this performance art then constituting the actual works of art. Their "photo-pieces" are precisely calculated definitions of situations.

George: "Everyone remembers being taken off as a child for that annual visit to the museum, and wanting to have nothing to do with the dreadfully boring rooms with all the pictures full of wigs and sailing ships – great art – but only being interested in the stuffed animals and the trains and the model ships. Real things. *We* want our works to be real – faithful, true to life. *We* want to be truthful. So if someone were to say: 'Don't you think your exhibition was depressing?', the answer would be: 'No more depressing than life.' *You* ask if our art is ironical. It is no more ironical than life. *We* consist of life, we're a part of life. *We* change the lives of many people who come to our exhibitions. So our paintings have to have this realness. They are real things."

51 • Shag Stiff. 1977. Photo-piece. 95:79 inches, 241:201 cm.
52 • Local Person. 1980. Photo-piece. 95:79 inches, 241:201 cm.
53 • Gothick Attack. 1980. Photo-piece. 119:79 inches, 301:201 cm.
54 • Flight. 1983. Photo-piece. 95:119 inches, 241:301 cm.

• illustration in this catalogue

G., from the catalogue: Gilbert & George,
Munich 1986

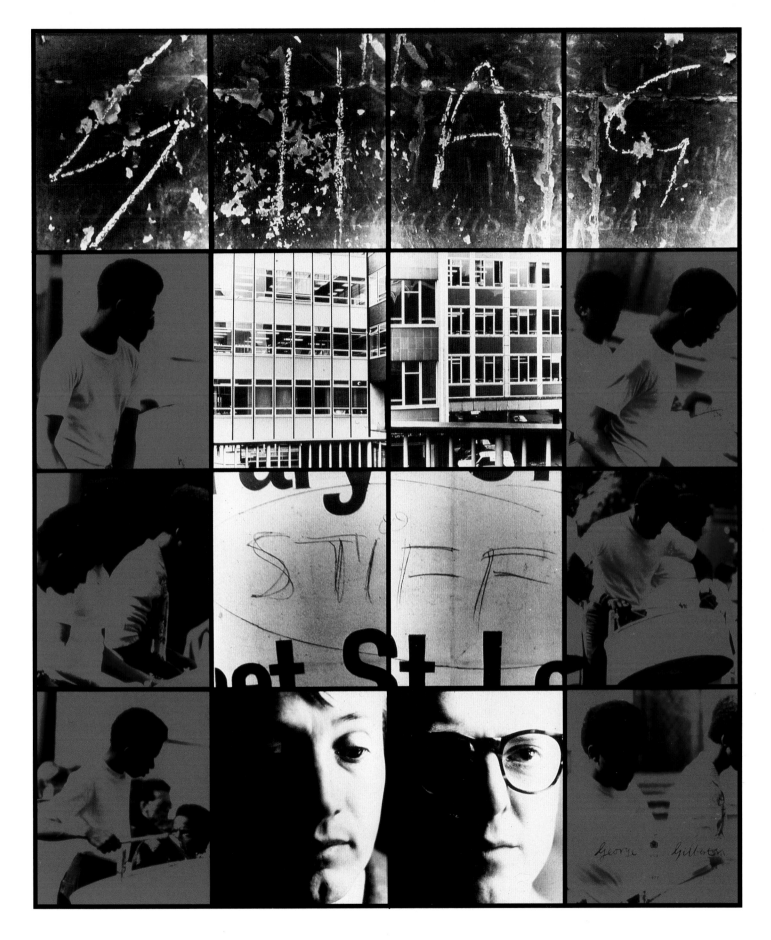

51 Shag Stiff. 1977. Photo-piece. 95:79 inches

Gilbert & George

52
Local Person. 1980
Photo-piece
95 : 79 inches

Gilbert & George

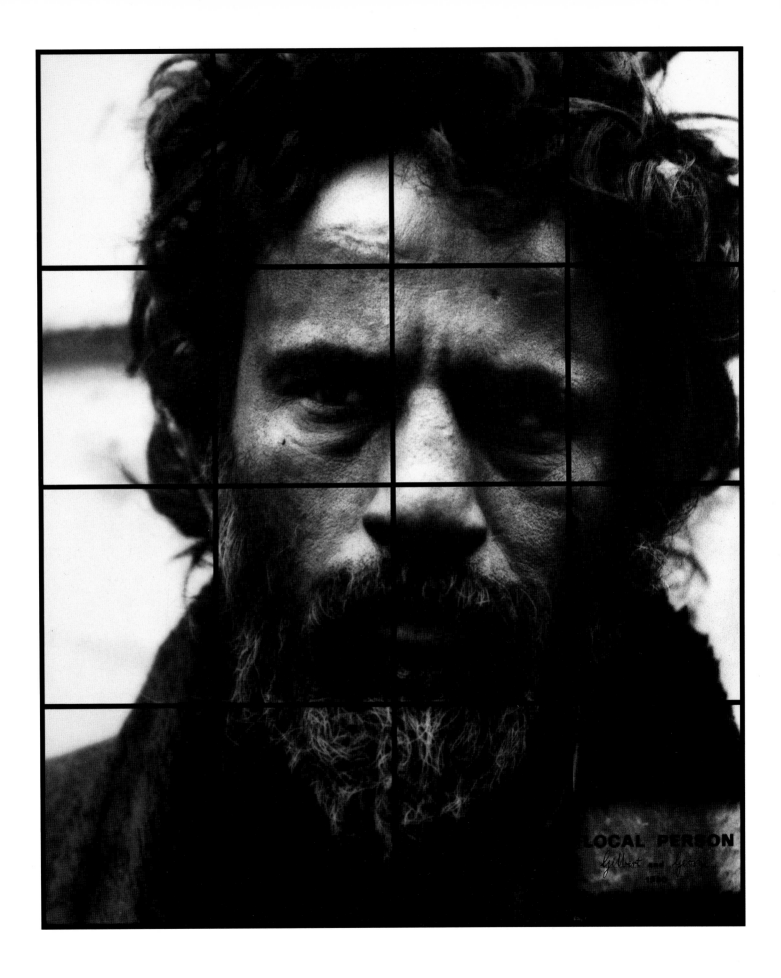

53
Gothick Attack. 1980
Photo-piece
119:79 inches

Gilbert & George

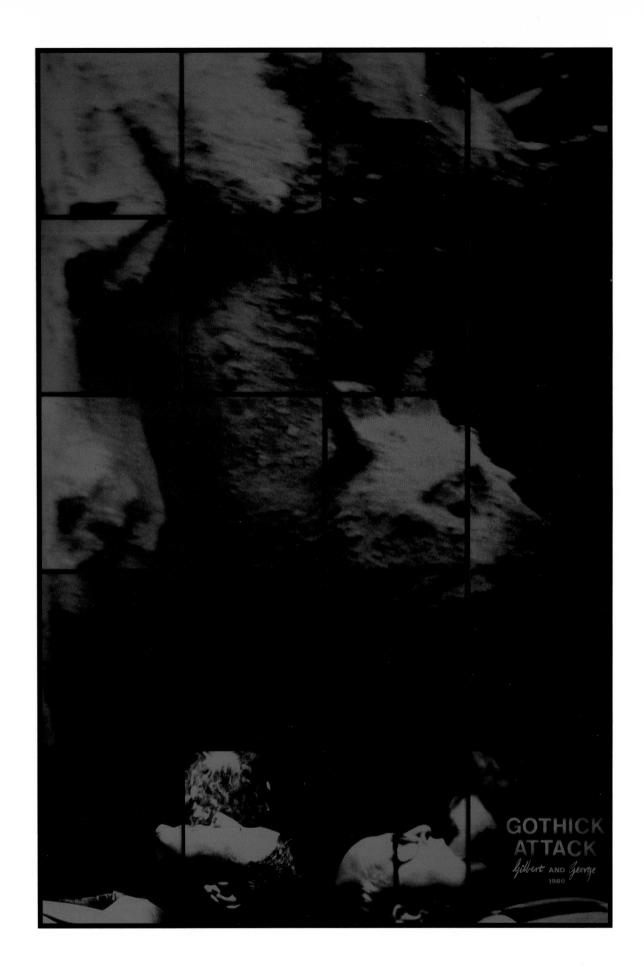

GOTHICK
ATTACK
Gilbert AND *George*
1980

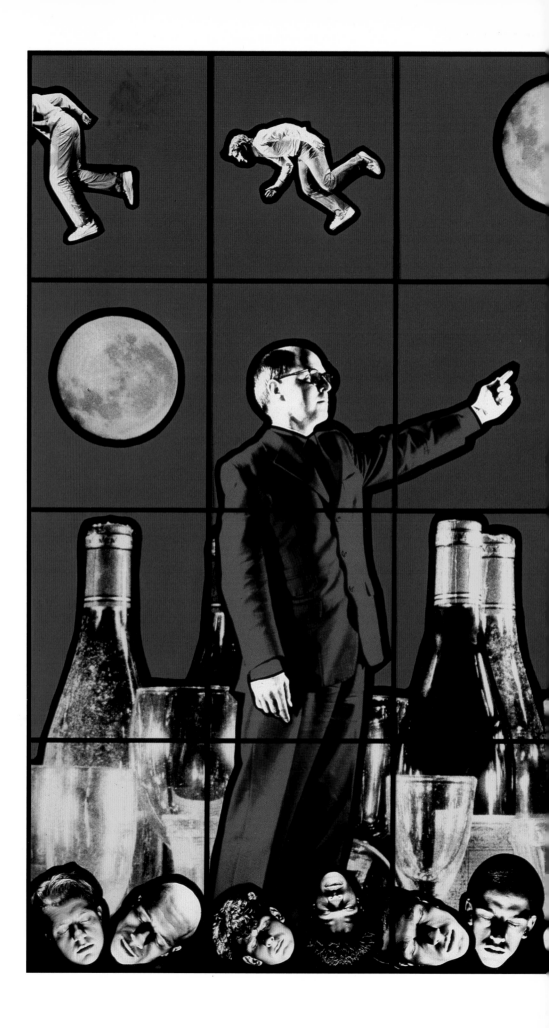

54
Flight. 1983
Photo-piece
95:119 inches

Gilbert & George

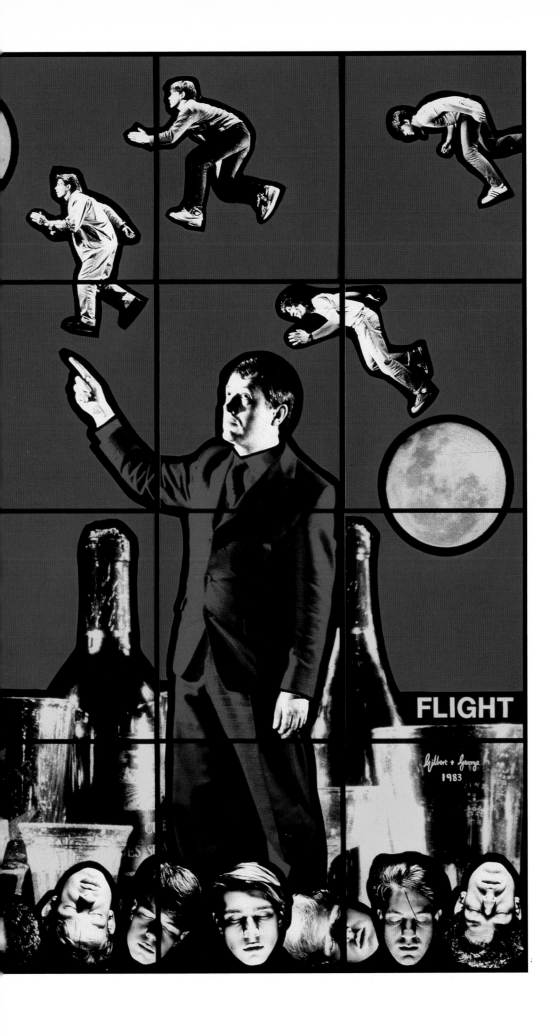

Rolf Iseli

Iseli, Rolf
Born 1934 in Bern, Switzerland
Lives and works in Bern and St-Romain

1950–54 did an apprenticeship in photogravure and colour lithography; attended courses at the College of Commercial Art in Bern; spent time in Paris in 1955, in New York in 1962 and in China in 1976.

The Swiss artist works as a painter, draughtsman and graphic artist. He is interested in the metamorphoses of things he has seen.

"When I'm painting, I sometimes have the urge to slip out of my own skin, to become the painting, to paint my own body or cover it completely with earth." (1978)

"My earth paintings will not hang in the museums of the future as paintings, but as precious relics of real earth – when we have all been completely concreted over." (1978)

55 • Untitled. 1960/61. Oil on canvas. 77½:61¾ inches, 197.2:156.8 cm.
56 • Erdbild. 1972. Acrylic, earth, graphite and ink on paper. 41:60¼ inches, 104:153 cm.
57 • L'Homme de Périgord. 1971–75. Watercolor, pencil on paper. 60¼:40⅞ inches, 152.8:103.9 cm.
58 • Homme Cactüsse de Terre. 1973. Acrylic, earth, straw on paper. 26:19½ inches, 66:50 cm.
59 • Chläbstreifeblatt. 1975. Acrylic, rush, tape, charcoal and ink on paper. 43¼:31⅛ inches, 110:79 cm.
60 • Grosser roter Federmann. 1976. Acrylic, earth and feathers on paper. 42½:62¼ inches, 108:158 cm.
61 ça coule. 1977. Acrylic, pencil and earth on paper. 39⅜:74¾ inches, 100:190 cm.
62 Der Maler als Photograph. 1978. Acrylic, wood, mushrooms and earth on paper. 43¼:31⅛ inches, 110:79 cm.
63 Negubouquet. 1981. Nails, peat, earth and acrylic on paper. 40⅜:69⅝ inches, 102.5:177 cm.
64 • Grosser Horcher. 1982. Acrylic, pastel, charcoal and graphite on paper. 58⅞:40¾ inches, 149.5:102.5 cm.
65 Gleichwertig. 1983. Acrylic, charcoal, nails and wire on paper. 43:30¼ inches, 109:77 cm.
66 • Steigring, 2. Fassung St. Romain. 1984. Acrylic, watercolor, graphite, charcoal, earth, powder-paint on paper. 60⅝:41¼ inches, 154:105 cm.

67 Eisenzüpfe. 1971. Iron. Length: 10¼ inches, 26 cm.

68 Périgord, 1. Zustand. 1980. Dry point etching. Reworked with graphite and earth, state 1 of 18. Papersize: 67:35 inches, 170.5:89 cm. Printsize: 58⅝:33 inches, 149:84 cm.
69 Horcher St. Romain Genf. 1982. Dry point etching VI/VII 1/1. Papersize: 66⅜:35 inches, 166:89 cm. Printsize: 58⅝:32⅝ inches, 149:83 cm.

• illustration in this catalogue

R. I., from the catalogue: Rolf Iseli,
Hanover 1984

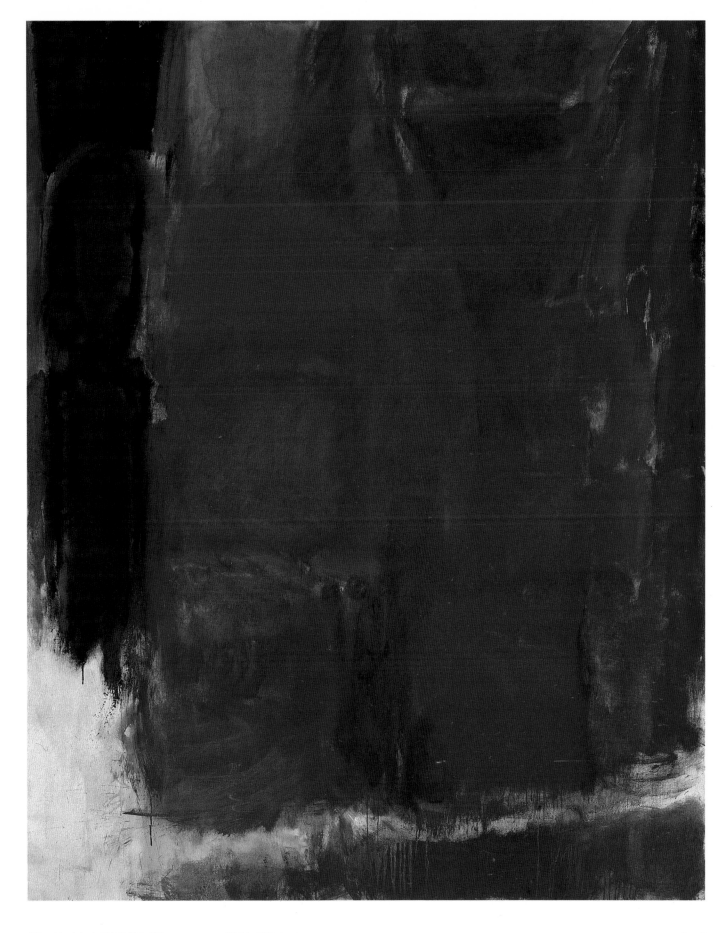

55 Untitled. 1960/61. Oil on canvas. 77½ : 61¾ inches **Iseli**

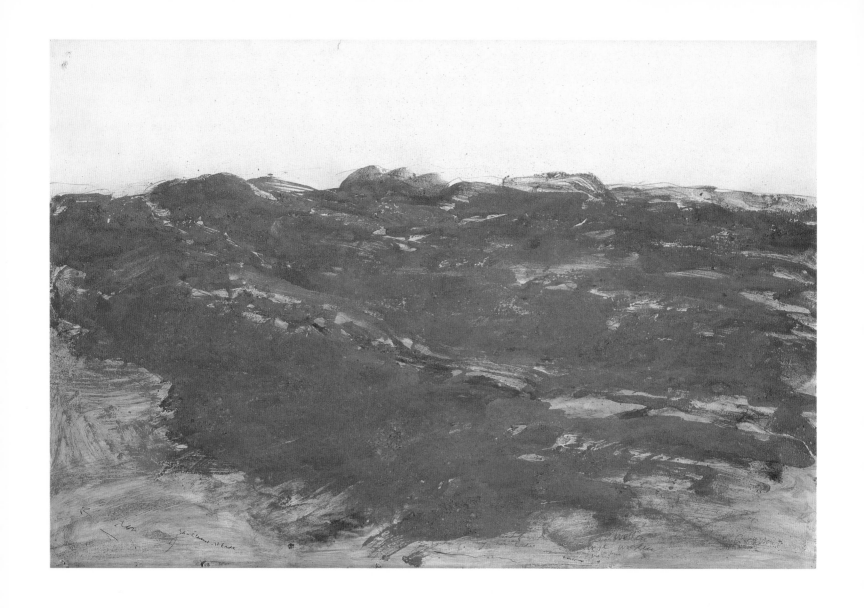

56
Erdbild. 1972
Acrylic, earth, graphite and ink on paper
41:60¼ inches

Iseli

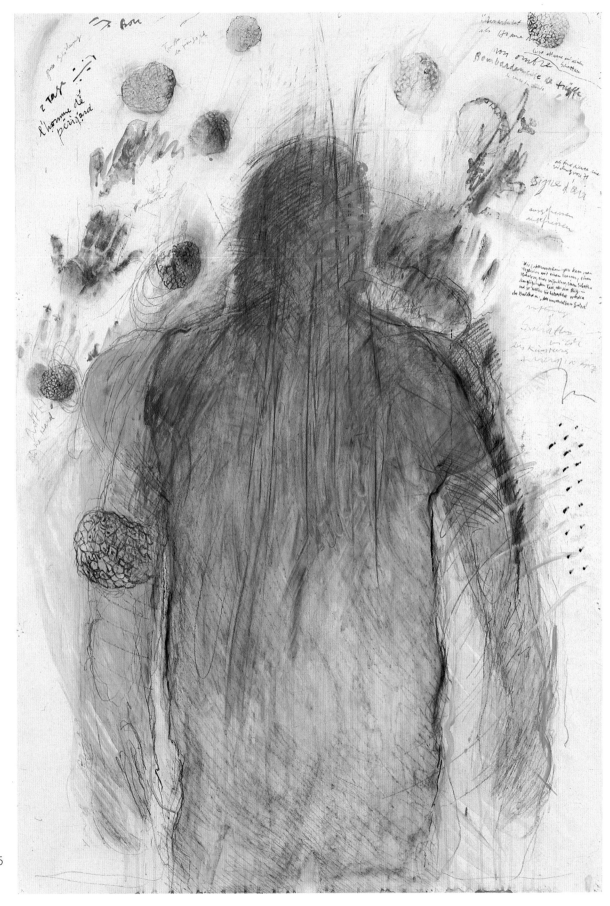

57
L'Homme de Périgord. 1971–75
Watercolor, pencil on paper
60¼ : 40⅞ inches

Iseli

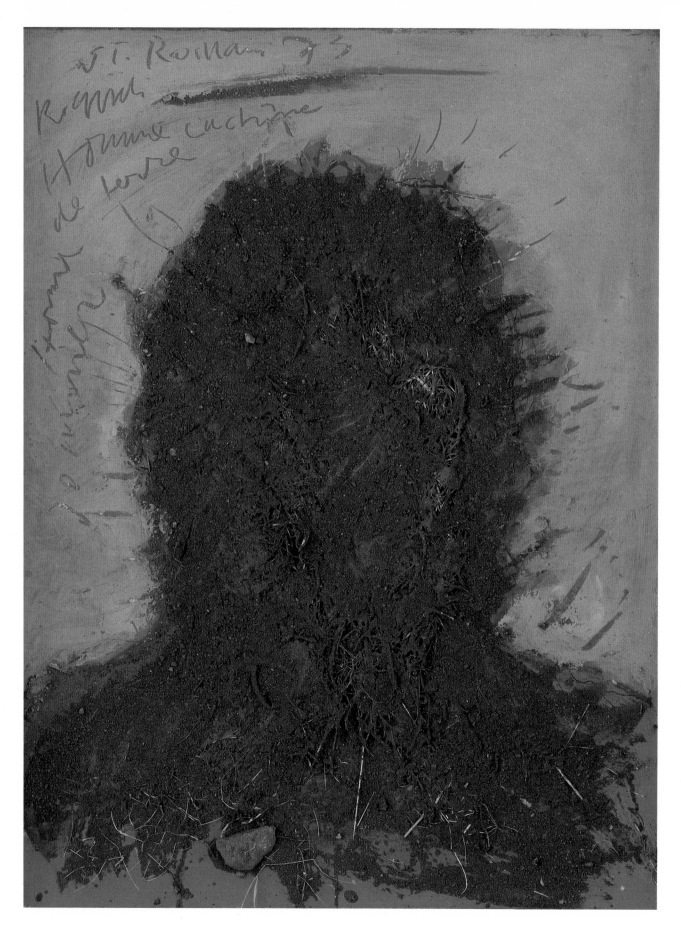

Iseli 58 Homme Cactüsse de Terre. 1973. Acrylic, earth, straw on paper. 26 : 19½ inches

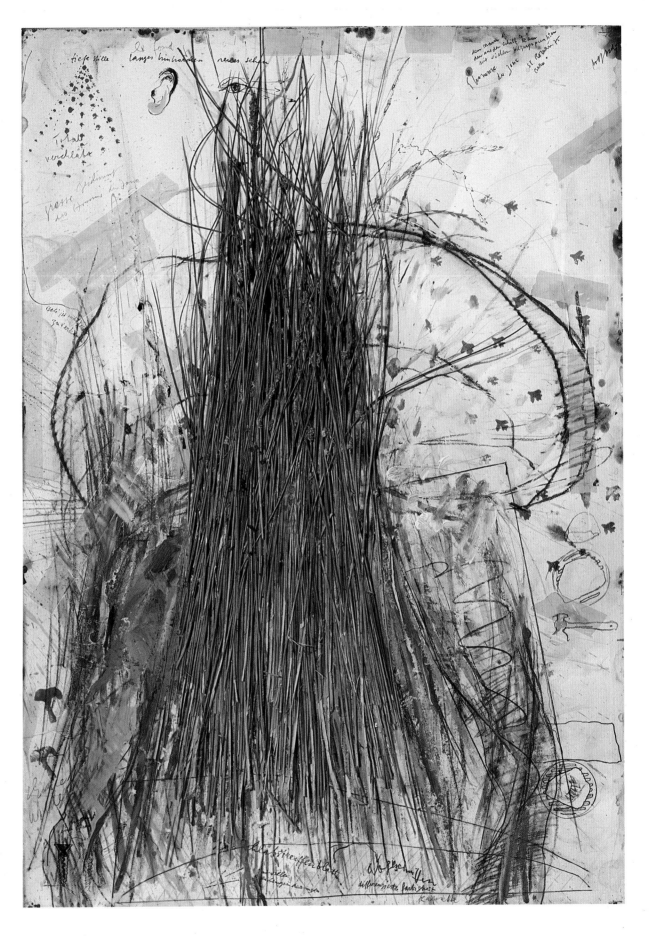

59 Chläbstreifeblatt. 1975. Acrylic, rush, tape, charcoal and ink on paper. 43¼ : 31⅛ inches

Iseli

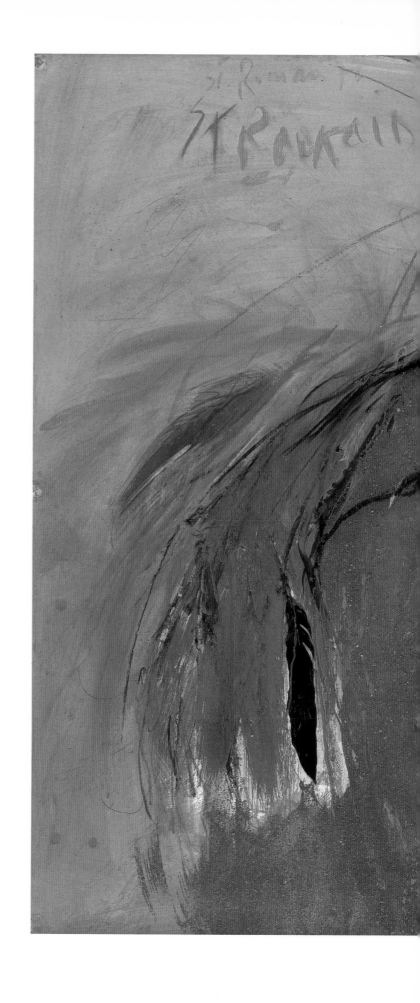

60
Grosser roter Federmann. 1976
Acrylic, earth and feathers on paper
42½ : 62¼ inches

Iseli

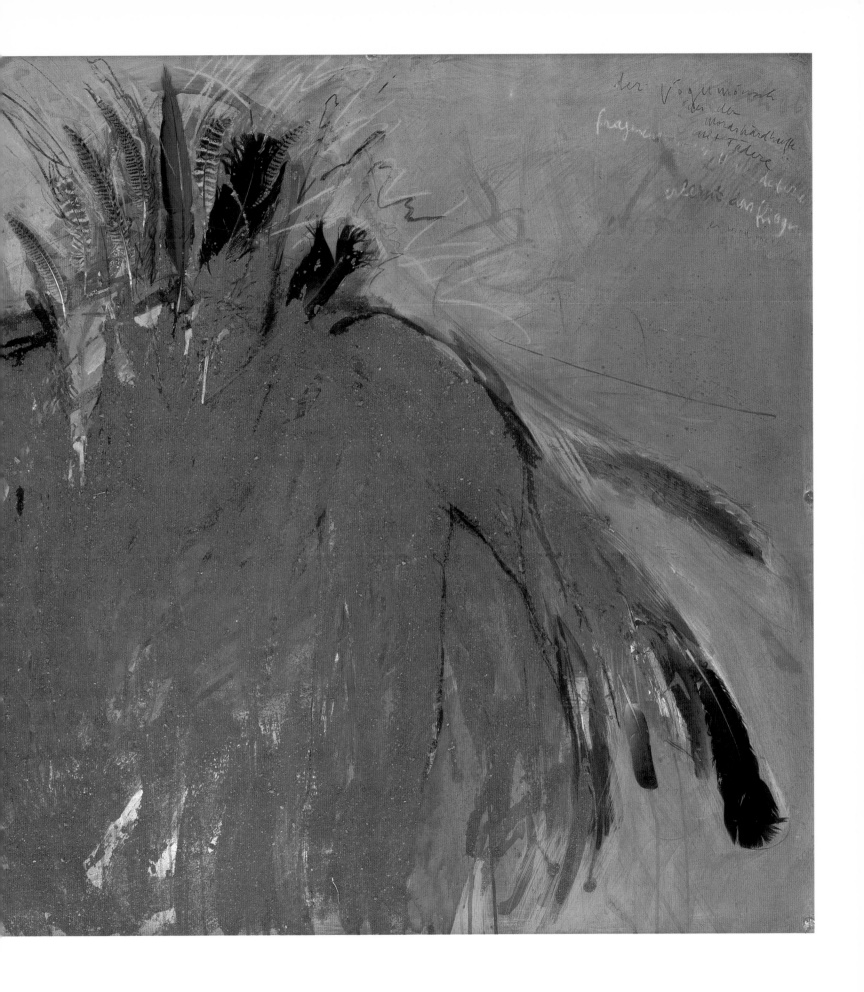

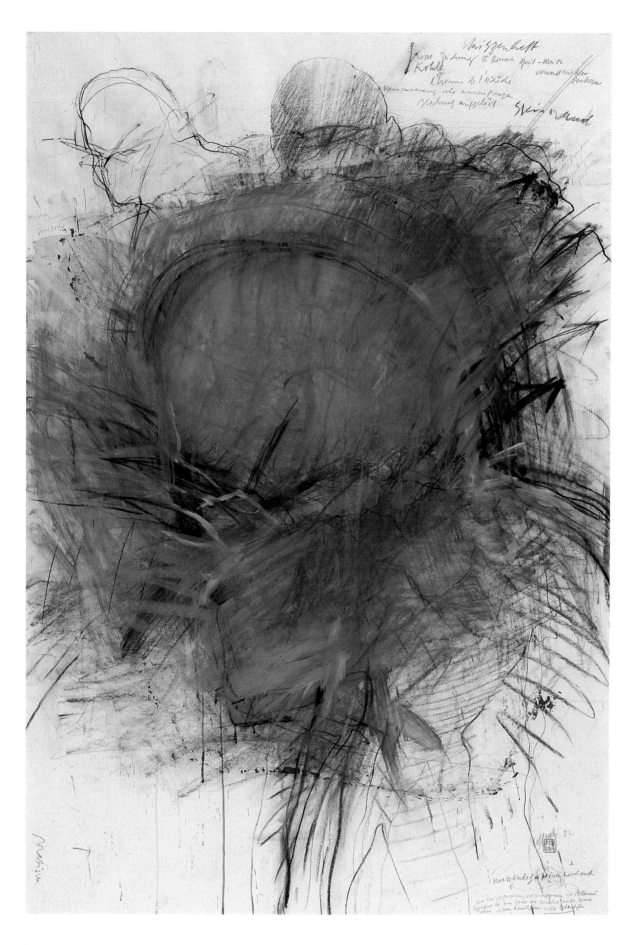

64
Grosser Horcher. 1982
Acrylic, pastel, charcoal
and graphite on paper
58⅞ : 40¾ inches

Iseli

92

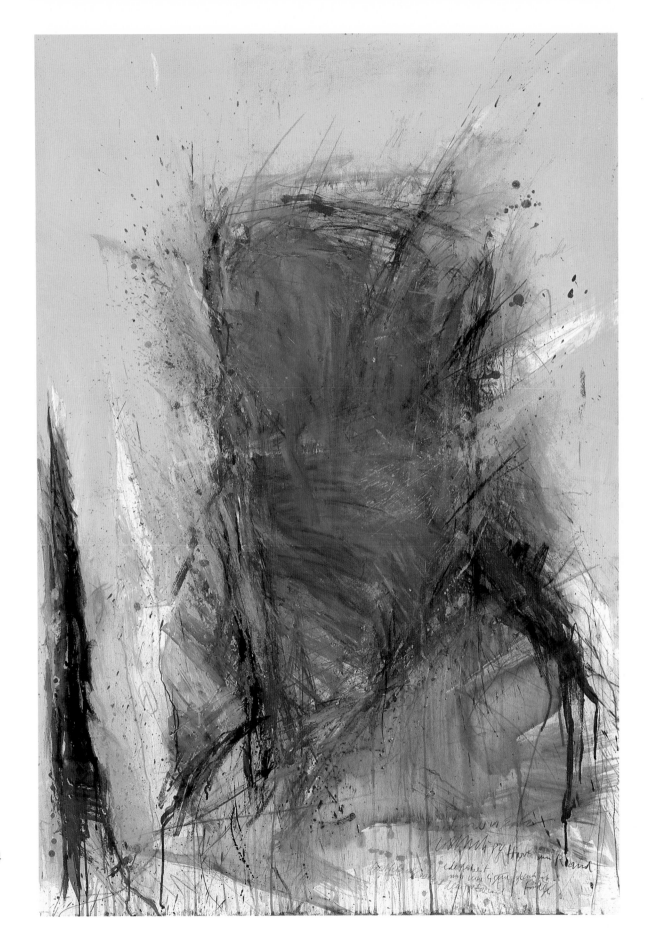

66
Steigring,
2. Fassung St. Romain. 1984
Acrylic, watercolor,
graphite, charcoal, earth,
powder-paint on paper
60⅝ : 41¼ inches

Iseli

Alfred Jensen

Jensen, Alfred

Born 1903 in Guatemala City, Guatemala
Died 1981 in Glen Ridge, New Jersey

Son of European immigrants;
1910–19 went to school in Denmark;
1925–26 studied at the Fine Arts
Museum in San Diego; 1927–28 stud-
ied with Hans Hofmann in Munich;
1957 started painting in his own
right; 1972 moved from New York
to Glen Ridge.

"In painting I can achieve a sensa-
tion because as I paint I show the
visual in its reciprocal relationships
at interplay acted out between
neighboring number structures.
I also show the interplay that exists
between number and color areas.
 As a painter I can paint these
correlations; but as a writer it is a
very hard task for me to attempt to
express in words what I think as a
painter..."

70 • Sphinx of the South. 1960. Oil on canvas. 72:46 inches, 183:116.5 cm.
71 • Twice Six and Nine. 1961. Oil on canvas. 24:42 inches, 60.8:107 cm.

• illustration in this catalogue

Letter from A. J. to Allan Kaprow, dated
24th September 1969
From the catalogue: Alfred Jensen,
Hanover 1973

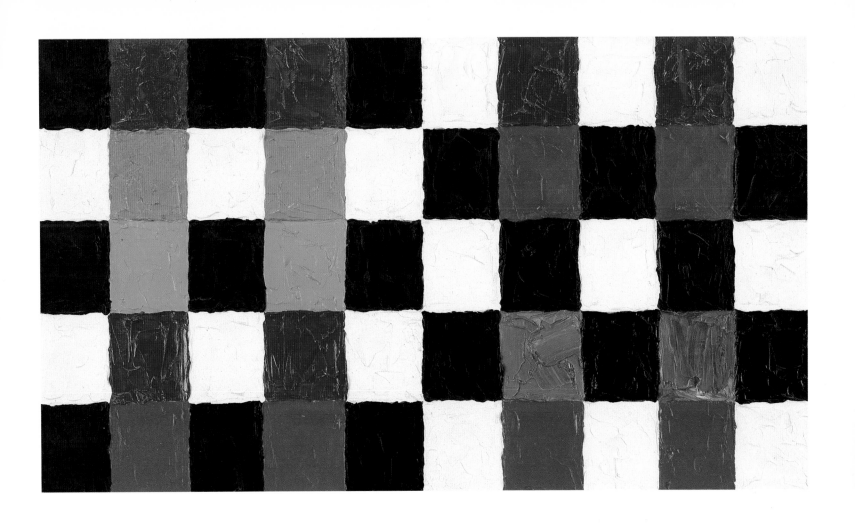

71 Twice Six and Nine. 1961. Oil on canvas. 24:42 inches

Jensen

70
Sphinx of the South. 1960
Oil on canvas
72 : 46 inches

Jensen

Per Kirkeby

Kirkeby, Per
Born 1938 in Copenhagen, Denmark
Lives and works in Copenhagen, Laesø and Karlsruhe

Left school in 1957 and began to study natural sciences. Landscape painting, abstract painting, environments and happenings. 1966/67 New York, 1978 Karlsruhe, 1982 Berlin.

The Dane paints, sculpts, writes poetry and makes films. As a geologist, he is interested in abstract, structural, interior landscapes.

"Last summer, on a day when it wasn't raining, in a bookshop in Salzburg, I found a highly ornamented and grotesque initial E. On page 379 (I made a note of the page after searching so many times through all the 766 pages looking for it) of a photographically reproduced paperback edition of Theodor Fontane's 'Der Deutsche Krieg', first published in 1866. I'm not interested in the author and certainly not in this particular book, it's too fat and as far as the illustrations are concerned, I already have plenty of material in similar style on the war between Germany and France. No, I bought it because my thick-skinned thumb stumbled upon this E. And without really knowing why, I just had to bring the book home with me. Even though my thrifty disposition which almost verges on meanness was sorely tried by every aspect of the purchase of the tome. And then having to carry it as well. But I bought it. For my paintings. The way other people buy food for their pets."

P.K., from the catalogue: Per Kirkeby, Salzburg 1986

72 • Untitled. 1978. Oil on canvas. 80¼:94 inches, 204:239 cm.
73 • Einsames Pferd. 1983. Oil on canvas. 78¾:98⅜ inches, 200:250 cm.
74 • Untitled. 1983. Oil on canvas. 78¾:137¾ inches, 200:350 cm.

75 • Der kleine Kopf mit Arm. 1981. Bronze 2/6. 13¾:5½:8¾ inches, 35:14:22 cm.
76 • Model: Zwei Arme II. 1981. Bronze (Unique). 16½:28¾:12¼ inches, 42:73:31 cm.
77 • Figure. 1983. Bronze 1/6. 83:19¼:26¾ inches, 211:49:68 cm.
78 • Torso II. 1983/84. Bronze 1/6. 77¼:48:18⅞ inches, 196:122:48 cm.

• illustration in this catalogue

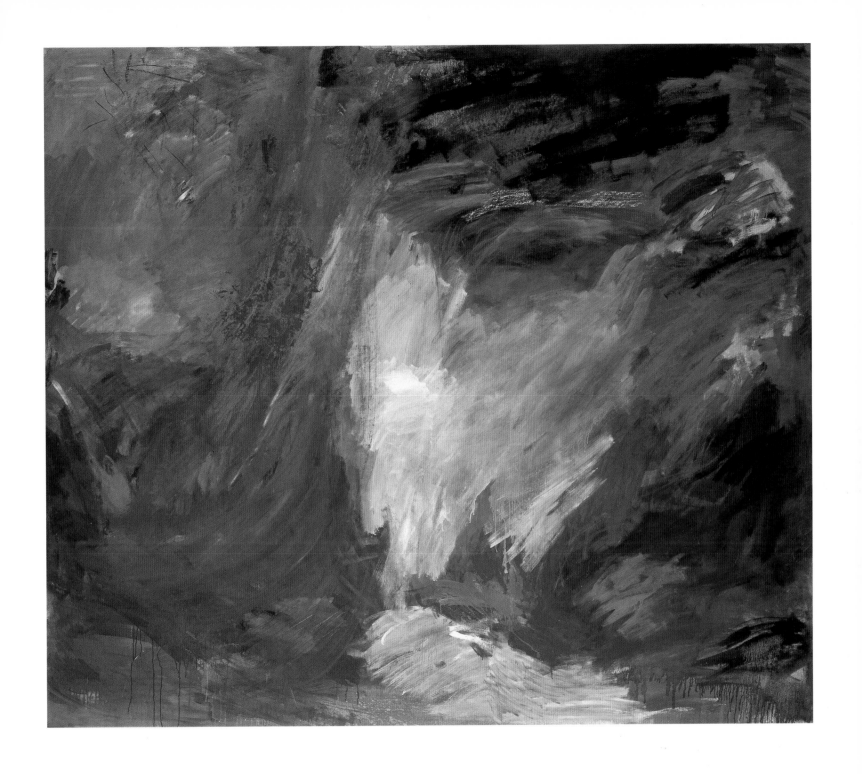

72 Untitled. 1978. Oil on canvas. 80¼ : 94 inches

Kirkeby

103

73
Einsames Pferd. 1983
Oil on canvas
78¾ : 98⅜ inches

Kirkeby

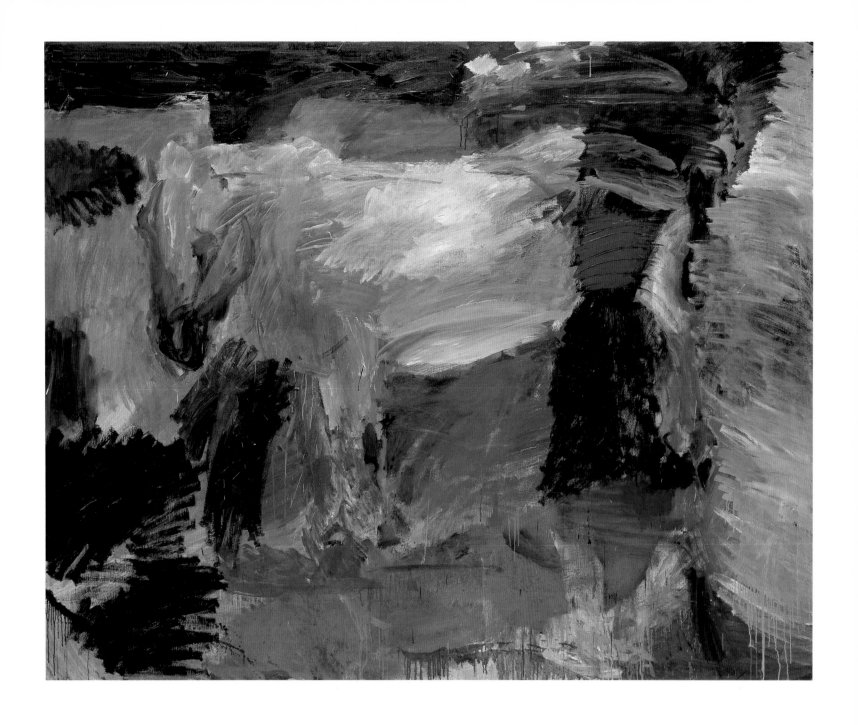

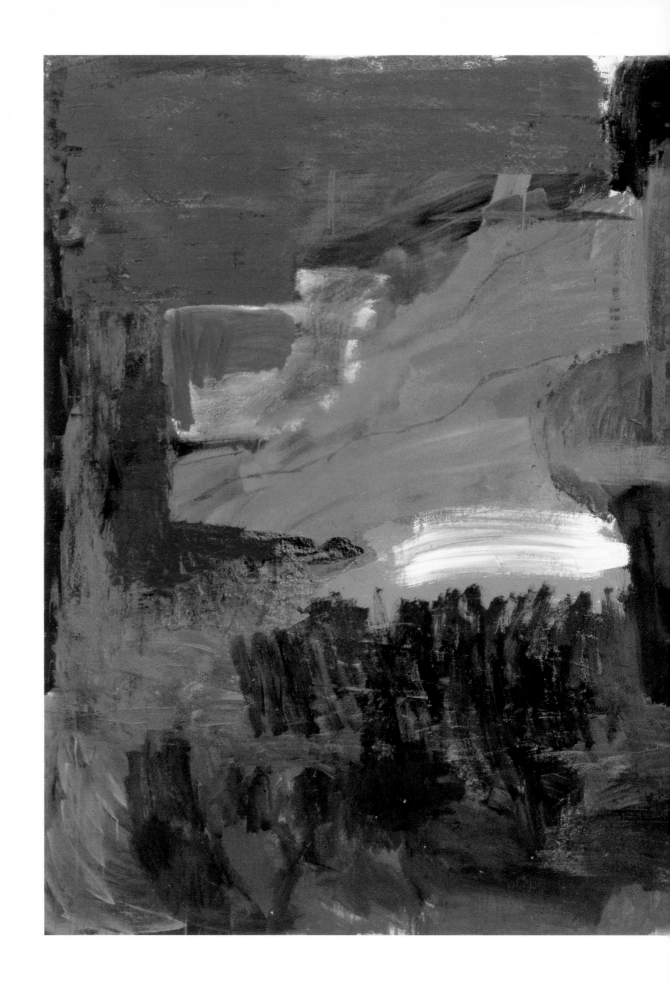

74
Untitled. 1983
Oil on canvas
78¾ : 137¾ inches

Kirkeby

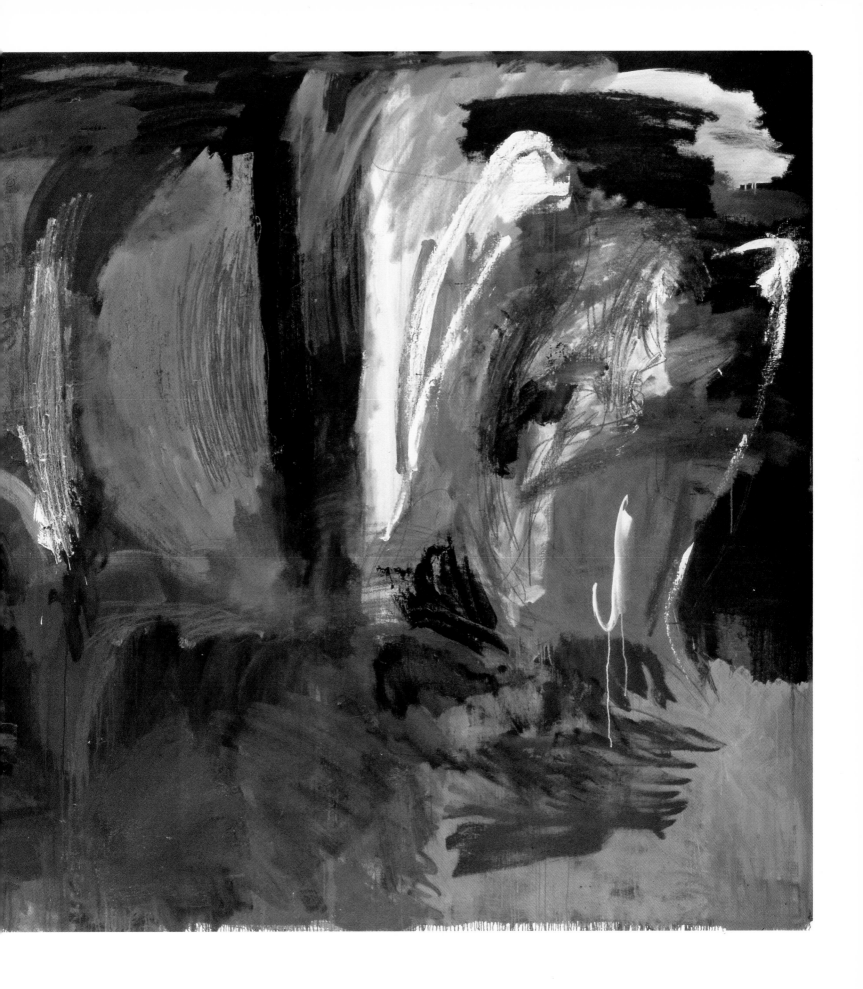

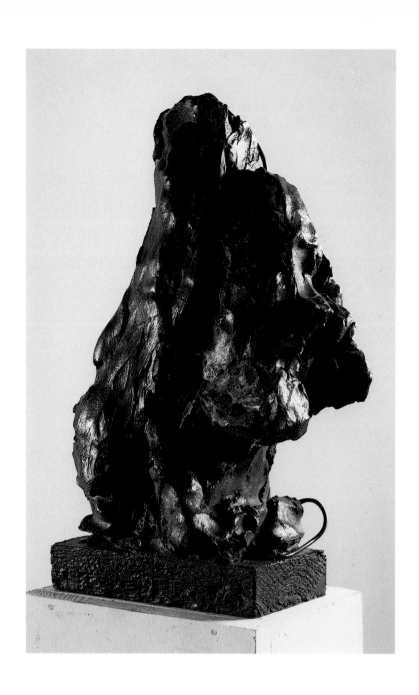

75 Der kleine Kopf mit Arm. 1981. Bronze 2/6. 13¾ : 5½ : 8¾ inches

Kirkeby

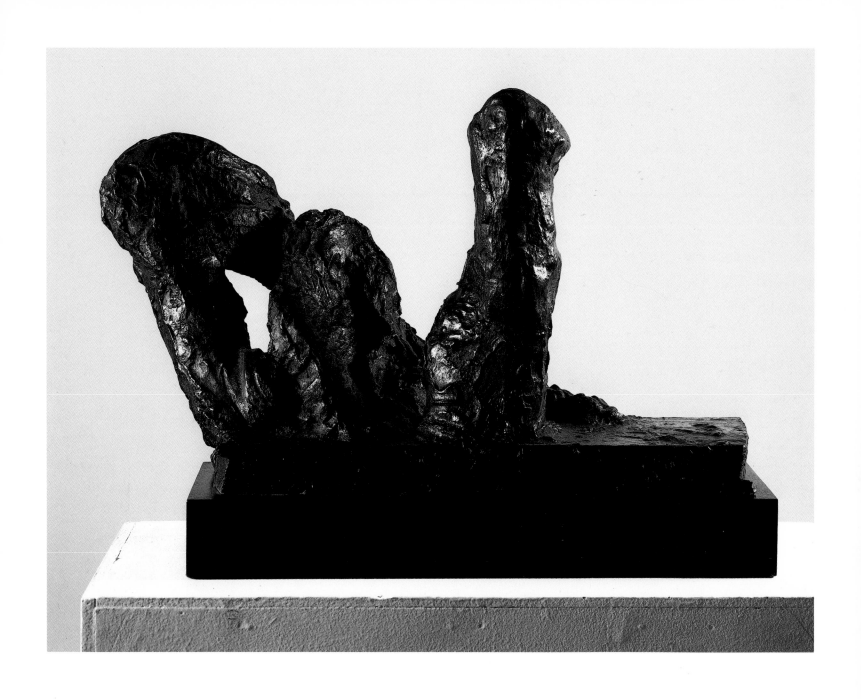

76 Model. Zwei Arme II. 1981. Bronze (Unique). 16½ : 28¾ : 12¼ inches

Kirkeby

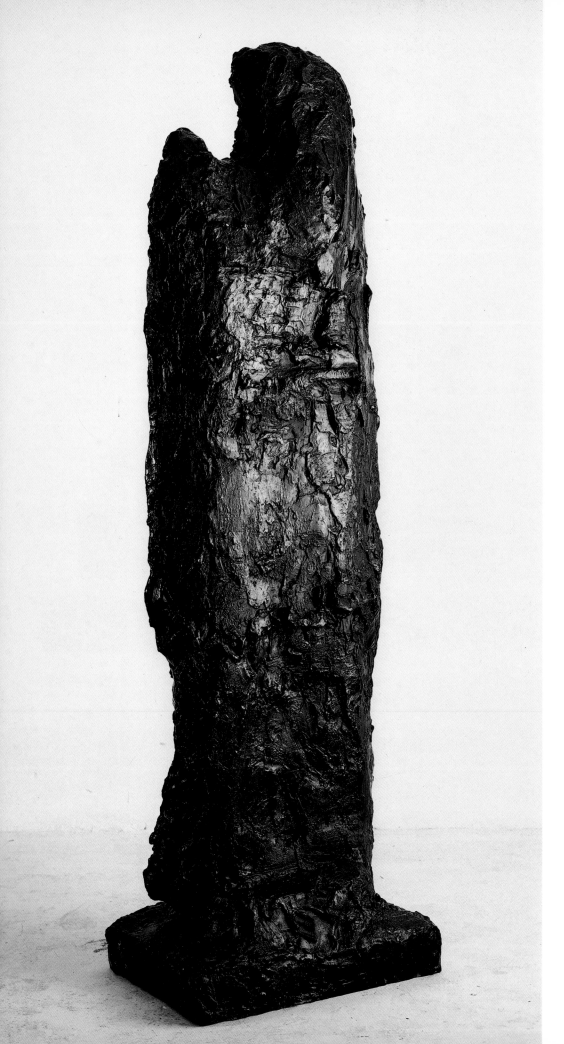

77
Figure. 1983
Bronze 1/6
83 : 19¼ : 26¾ inches

Kirkeby

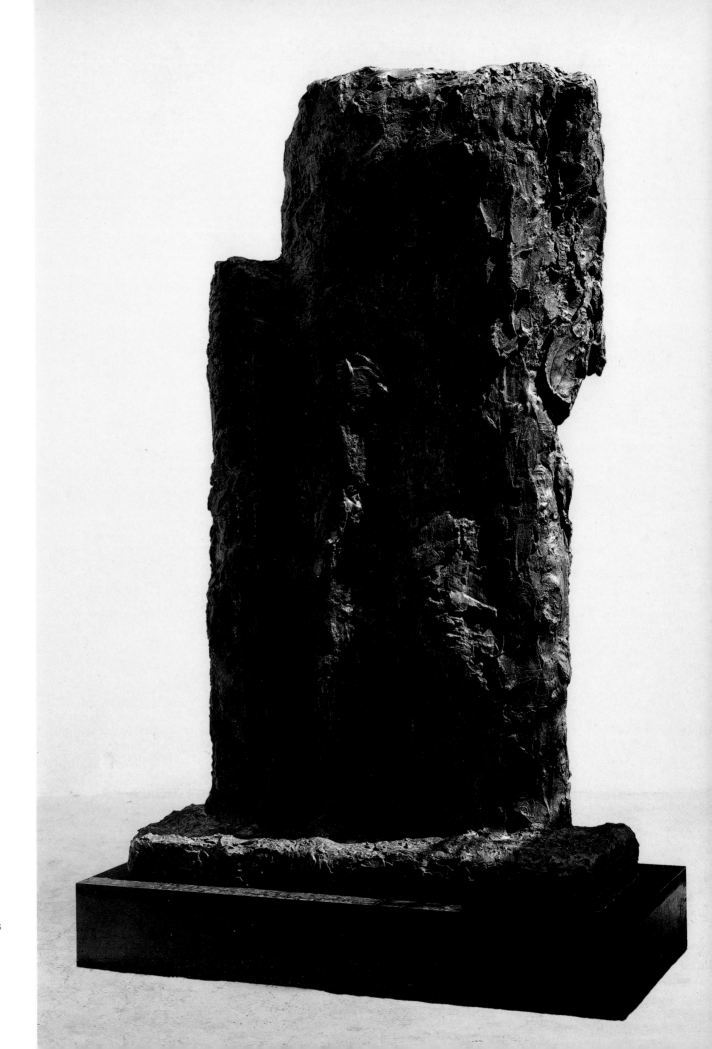

78
Torso II. 1983/84
Bronze 1/6
77¼ : 48 : 18⅞ inches

Kirkeby

Kriesche, Richard

Born 1940 in Vienna, Austria
Lives and works in Graz

1958 completed his schooling at the High School in Fürstenfeld; 1964 awarded Diploma in graphic art and painting from the Academy of Visual Arts in Vienna; has taught since 1969 at the Technical College in Graz; 1983 held an Artists-in-Berlin scholarship from the German Academic Exchange Programme (DAAD).

The Austrian practitioner of conceptual art gives a great deal of critical thought to the media and technology and their positive and negative sides.

"It is not the continuation of traditions, but the actual value in real terms for society that will be the criterion by which people will judge all their products, and that means art as well, when it's a question of their own survival and that of future generations. (First comes the question of survival, and out of that the question of style and of art. Not the other way round.)"

79 • Ein Weltmodell. 1986. Robot-installation. Each 27⅛ : 7⅞ : 23⅝ inches, 69 : 20 : 60 cm (depending on position).

• illustration in this catalogue

R. K., from the catalogue: Richard Kriesche, Humane Skulpturen, Graz 1985

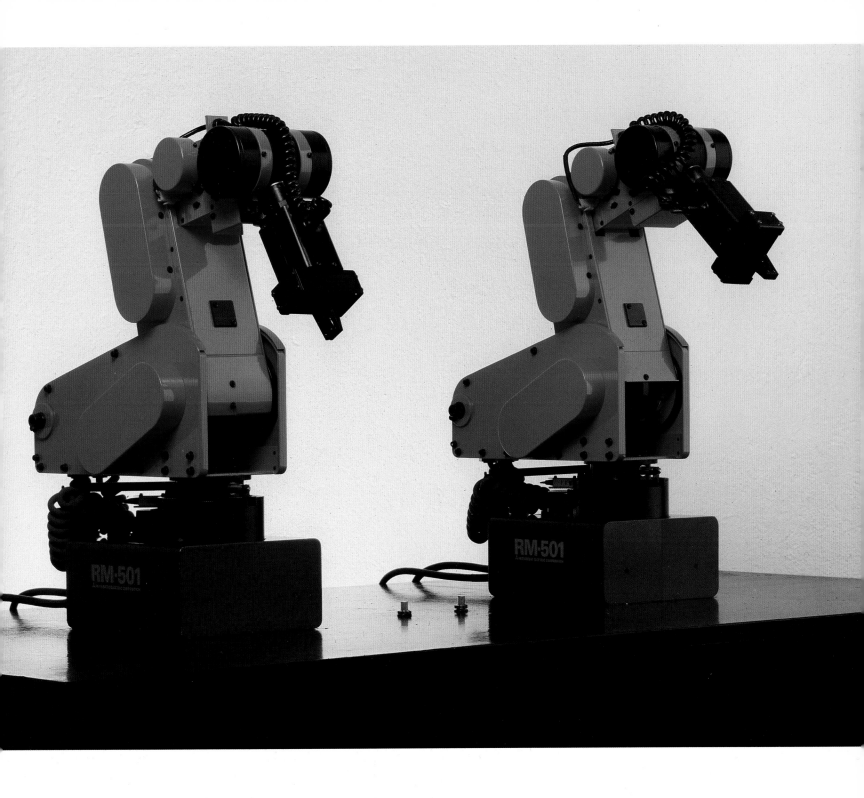

79 Ein Weltmodell. 1986. Robot-installation. Each 27⅛ : 7⅞ : 23⅝ inches (depending on position)

Kriesche

Morris Louis

Louis, Morris

Born 1912 in Baltimore, USA
Died 1962 in Washington DC

1929–33 studied at the Baltimore
Institute of Fine and Applied Arts;
1936 participated in the Federal Arts
Project/WPA in New York; 1940
Baltimore; 1952 Washington DC,
pioneer of color field painting;
like Pollock he paints on the floor,
the paint is applied directly to the
raw canvas so that the pure color
achieves the maximum optical
effect.
 Louis was one of the great Ameri-
can abstract painters who saw in art
the possibility of making visible a
view of the world that would not be
accessible to experience otherwise.
He was a painter; there are no
known written comments from him
on the subject of art.

80 • Alpha Nu. 1961. Acrylic on canvas. 105:179 inches, 266:455 cm.

 • illustration in this catalogue

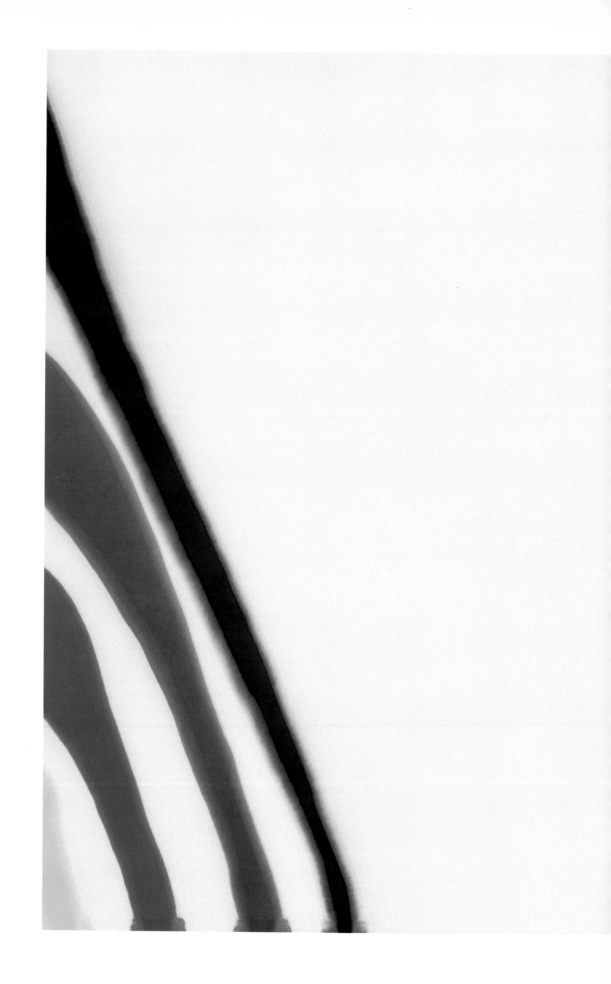

80
Alpha Nu. 1961
Acrylic on canvas
105 : 179 inches

Louis

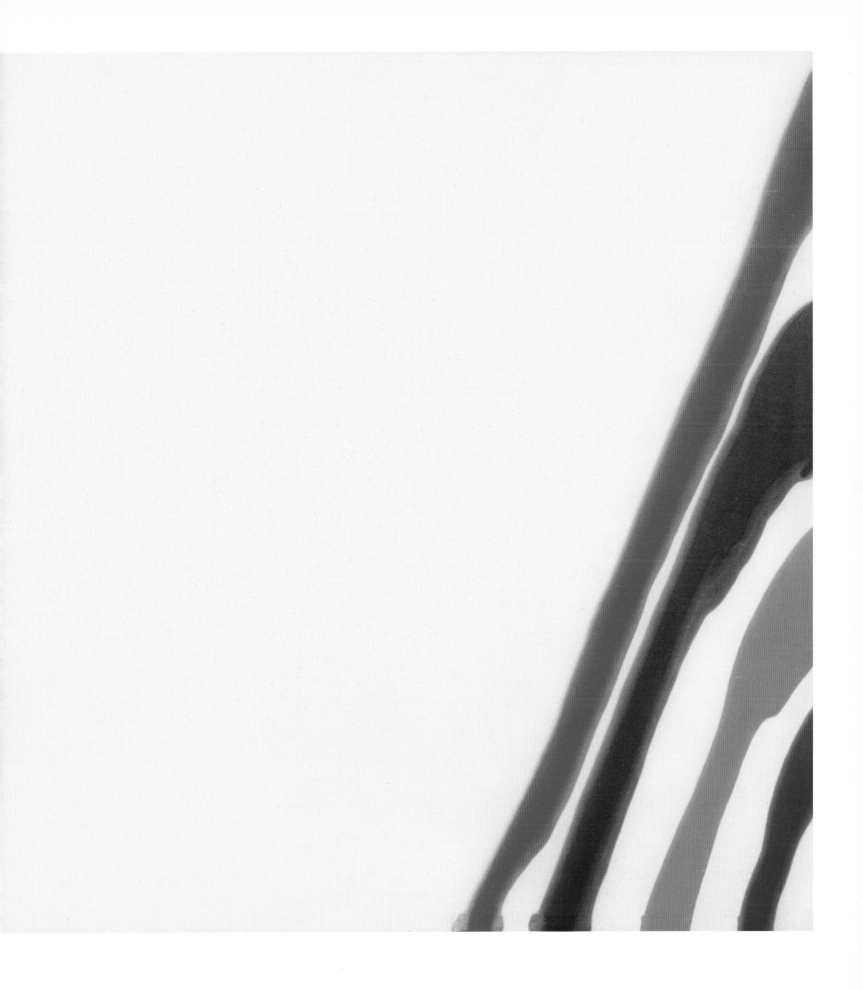

Leopoldo M. Maler

Maler, Leopoldo M.
Born 1937 in Buenos Aires, Argentina
Lives and works in California and Santo Domingo

1960 took a degree in Law
at the University of Buenos Aires.
Lived in London from 1961 to 1978.
Installations, video, performances,
films since 1964.
 Guggenheim Fellowship, 1977.
 First Grand Prize of the XIV Inter-
national Biennale of Art São Paulo
1977. First Dean of the "Parsons
School of Design Affiliation" in the
Dominican Republic, 1983–85.
 Maler works on visual metaphors
through multimedia art resources.
 1988: Monumental sculpture for
Seoul's Olympic Park.

"I believe much more in the creative
power of contemplation as the best
participatory attitude. And in that
respect I want my images to work like
catalysts, void of any narrative con-
tent, more as symbols of an un-
known religion, just as the mysteries
of one's own existence and mortality.
 I would like to travel the world
organising big celebrations, wed-
dings, birthday parties, staging fare-
well and welcoming ceremonies.
In short doing all those things that,
if enjoyed totally in a spirit of com-
munion with other human beings,
remove all meaning from the term
'artist' as an isolated manifestant
in society."

L. M., from the catalogue: Leopoldo
M. Maler, London 1976

81 • Hommage. 1974. Burning typewriter. 10½ : 19¼ : 12⅜ inches, 26.6 : 49 : 31.5 cm.

 • illustration in this catalogue

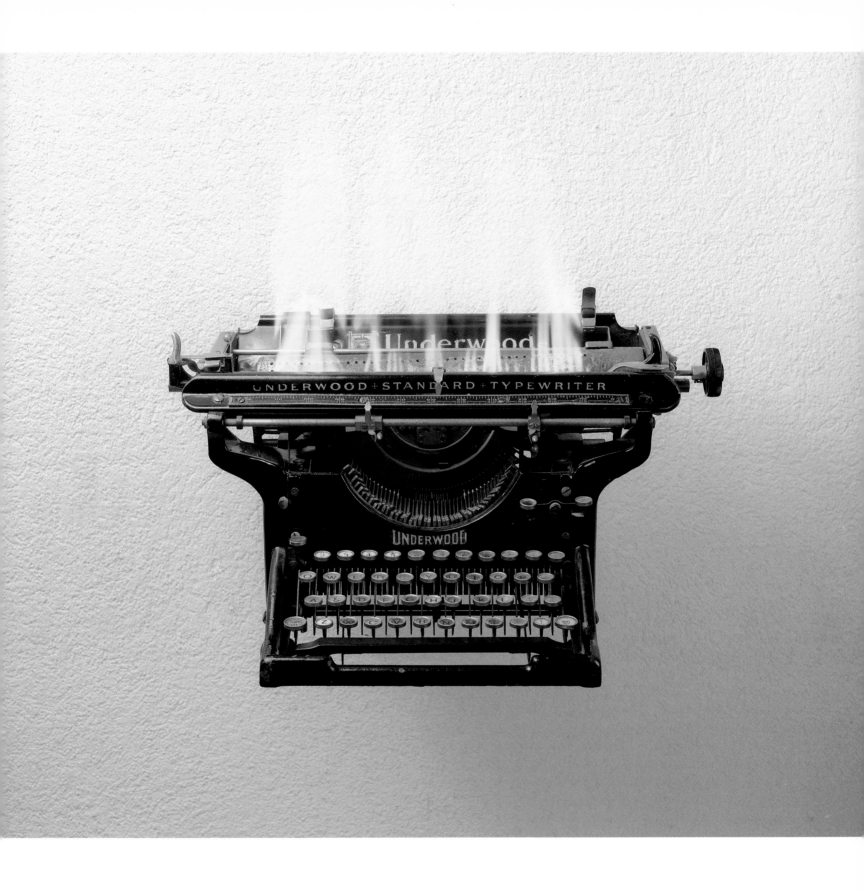

81　Hommage. 1974. Burning typewriter. 10½ : 19¼ : 12⅜ inches

Maler

Howard Mehring

Mehring, Howard

Born 1931 in Washington DC, USA
Died 1978 in Washington DC

Studied at Wilson College; travelled to England and Europe. Member of the Washington group of Colour Field Painters.

The American artist paints compelling pictures which have nothing of the mimetic about them. The painter's intuition is directed not towards copying something that exists, but creating something new in terms of retinal experience.

"My painting does not come from the easel. I prefer to work flat on the floor with the canvas unsized and unstretched. Raw canvas seems more open to me. I am closer to the painting, more in contact with it. Neither do I feel the sharp cut off of the edge of a stretched canvas.

I work rapidly and impulsively over the whole surface in waves of color. With thin washes I can achieve a sense of richness and depth ambiguously maintaining flatness. In this manner I can work with less danger of overloading and overworking. I weigh and mix each color carefully using each as an interior pressure working for expansion."

H. M., from the catalogue: Howard Mehring, Washington 1977/78

82 • Black. 1958. Magna and Charta. 101:103 inches, 257:261 cm.

• illustration in this catalogue

126

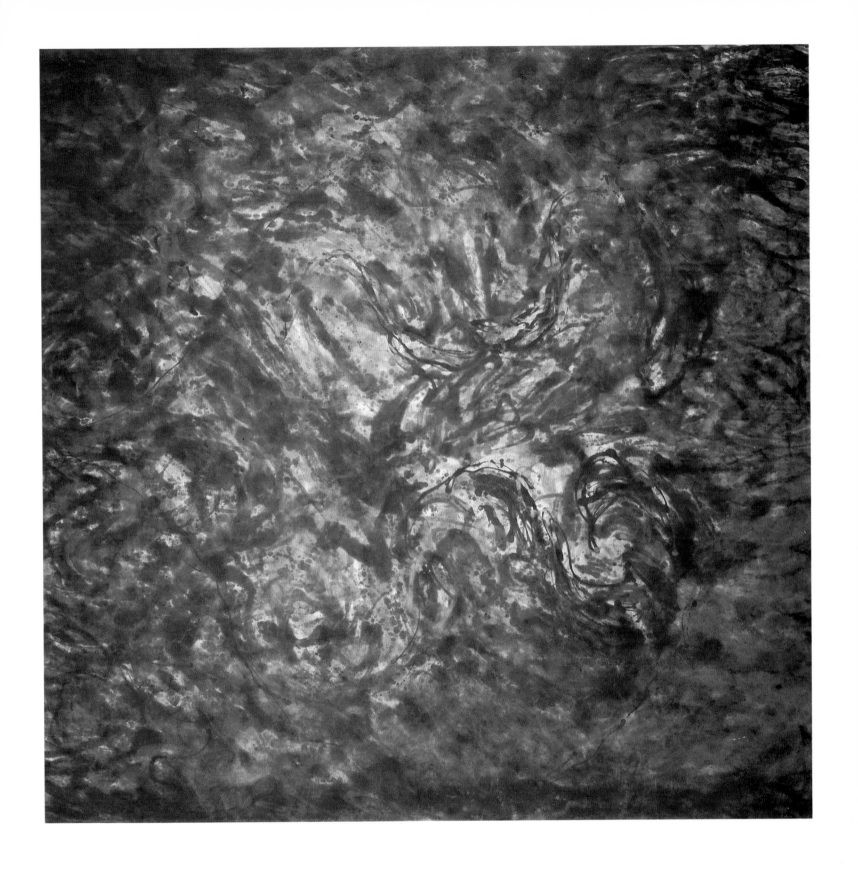

82 Black. 1958. Magna and Charta. 101:103 inches

Mehring

Henri Michaux

Michaux, Henri
Born 1899 in Namur, Belgium
Died 1984 in Paris

Started out as a writer, discovered painting in Paris in 1925; 1927 first essays in painting; 1927–37 travelled for ten years (Turkey, South America, India, China); 1940 fled from the Germans to the South of France; 1955 took French nationality.

The Franco-Belgian artist was concerned in his paintings and drawings with the inner depths of the human soul. He was not averse to using mescalin as a means of opening up new and uncontrolled resources of expression.

"Art is what helps to drag us out of inertia. What counts is not the impulse, nor the activating mainspring, but the vibrancy itself.

Achieving this mode is the goal – that is why one heads, consciously or not, for a state of supreme energisation, which is supremely intense, supremely fulfilling, supremely being. The rest is merely wood for the fire – or the flint.

Now this intensity is by no means a cause for revulsion (of course, it is – but only for some more clear-sighted than I!). No, it is this that I find most exciting and alluring.

As well as warring with my inherent inertia, from which it tears me, it is also the most high-powered weapon at my disposal in my battle with the outside world. It restores me, it supplies the answers to a hundred different problems, since I am often enough overwhelmed by life, or rather would be if it were not for this.

But I don't want to know this any more – at the moment I am in the country, with better things to do than think.

And after?

Well now, I see this above all as commotion. I am one of those people who loves commotion. Commotion the destroyer of inertia, the entangler of lines, the disturber of order. It frees me from all that is structured. Commotion, motion – disobedience, reinterpretation. That is what I love."

H. M., from the catalogue: Henri Michaux, Emergences – Résurgences, Geneva 1972

83 • Untitled. 1960. Watercolor on paper. 19⅝:25½ inches, 50:65 cm.
84 • Untitled. 1973. Acrylic on paper. 22:29½ inches, 56:75 cm.
85 • Untitled. 1974. Ink on paper. 52⅜:79¾ inches, 75.5:107.5 cm.
86 • Untitled. 1978. Acrylic on paper. 35½:63⅝ inches, 60:90 cm.
87 • Untitled. 1980. Ink on paper. 23¼:31⅛ inches, 59:79 cm.
88 • Untitled. 1982. Watercolor on paper. 22:15 inches, 56:38 cm.

• illustration in this catalogue

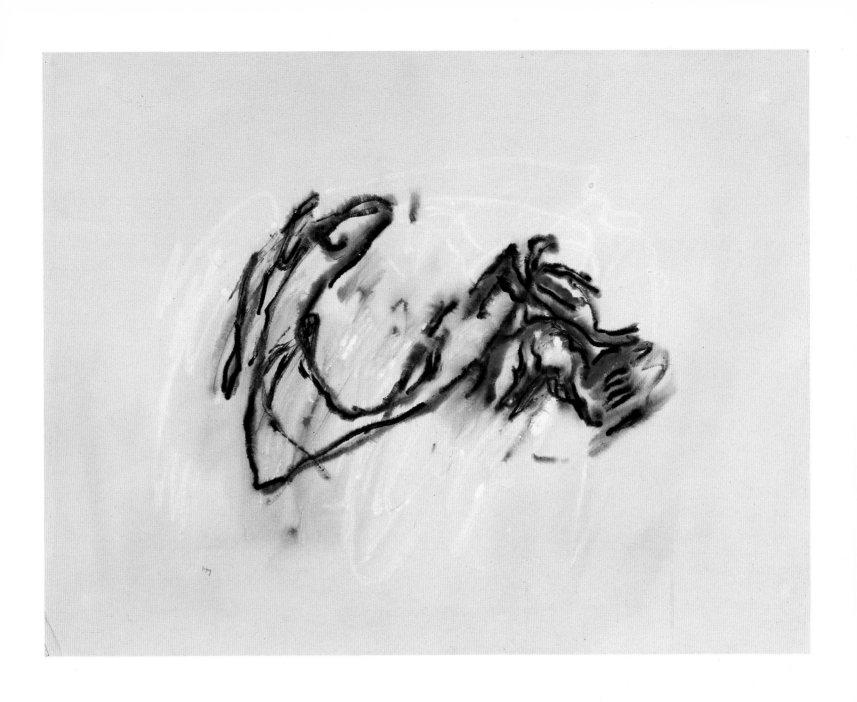

83 Untitled. 1960. Watercolor on paper. 19⅝ : 25½ inches

Michaux

84
Untitled. 1973
Acrylic on paper
22 : 29½ inches

Michaux

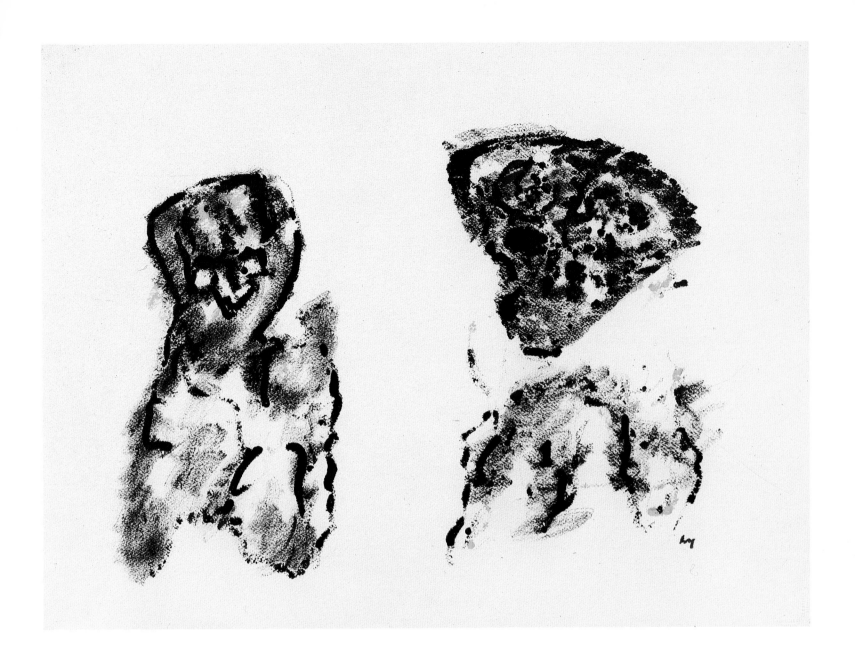

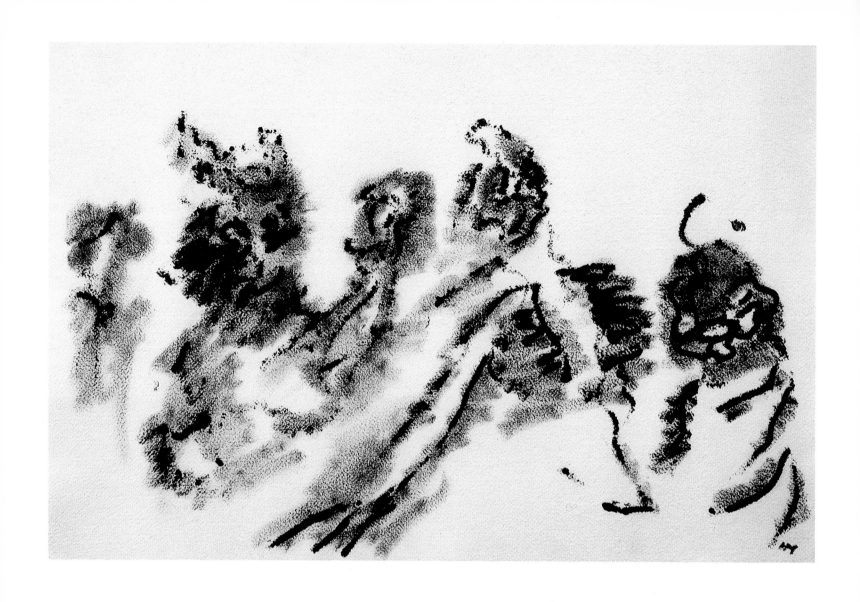

86 Untitled. 1978. Acrylic on paper. 35½ : 63⅝ inches

Michaux

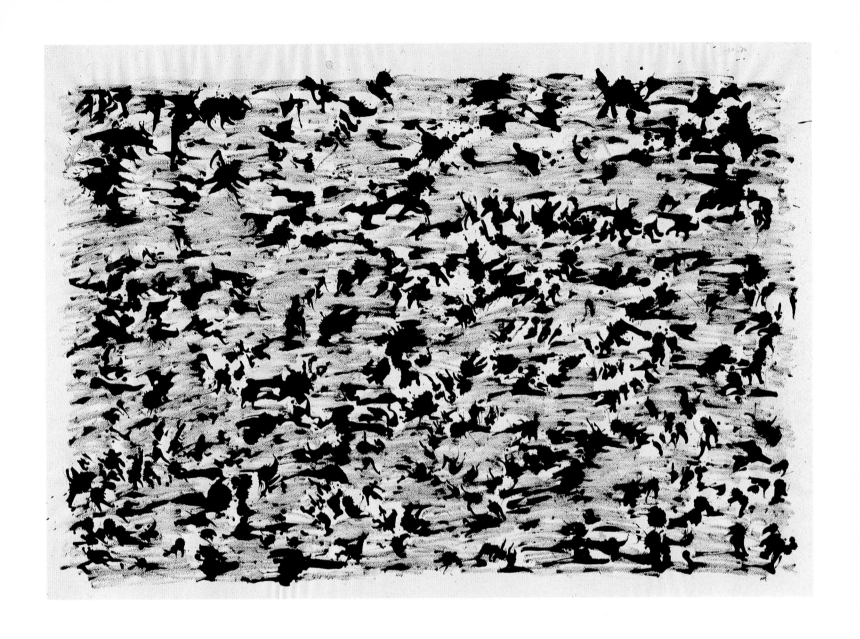

85 Untitled. 1974. Ink on paper. 52⅜:79¾ inches

Michaux

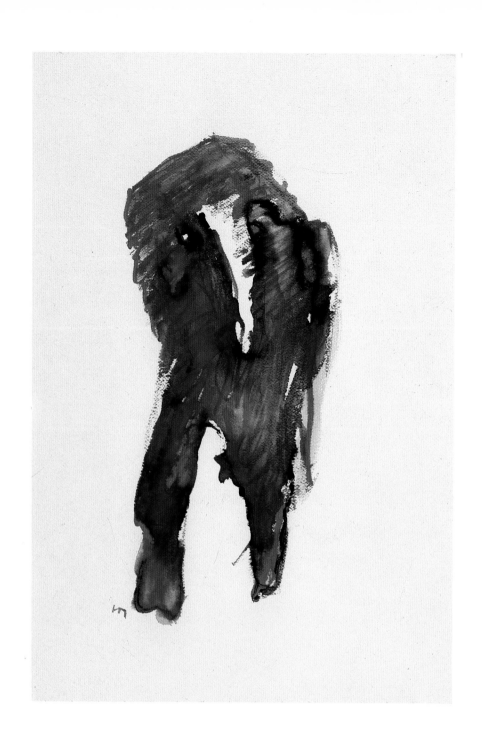

88 Untitled. 1982. Watercolor on paper. 22 : 15 inches

Michaux

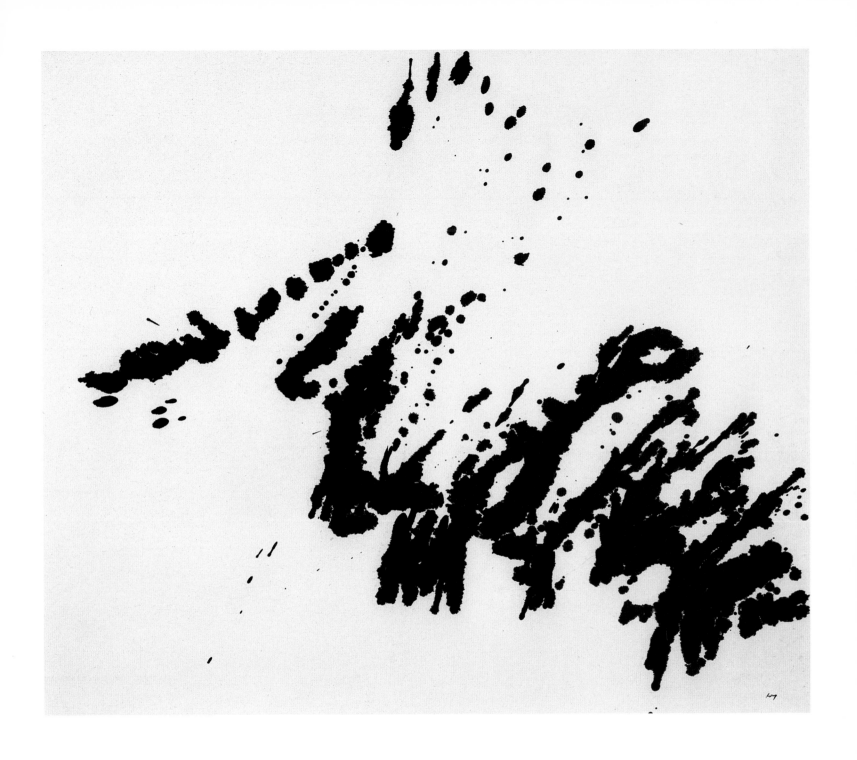

87 Untitled. 1980. Ink on paper. 23¼ : 31⅛ inches

Michaux

Robert Motherwell

Motherwell, Robert

Born 1915 in Aberdeen, Washington, USA
Lives and works in Greenwich, Connecticut

1932 California School of Fine Arts, 1932–37 Stanford University, Palo Alto, California; 1937–38 studied philosophy at Harvard University, Cambridge, Massachusetts; 1938–39 Paris, 1941 New York.

Like Stamos, Motherwell was a founder member of the American school of Abstract Expressionism. In his paintings, drawings, collages and graphics, the American artist pursues inner visions as other forms of truth.

"... In the end I realize that whatever 'meaning' that picture has is just the accumulated 'meaning' of ten thousand brush strokes, each one being decided as it was painted. In that sense, to ask 'what does this painting mean?' is essentially un-answerable, except as the accumu-lation of hundreds of decisions with the brush. On a single day, or during a few hours, I might be in a very par-ticular state, and make something much lighter, much heavier, much smaller, much bigger than I normally would. But when you steadily work at something over a period of time, your whole being must emerge..."

R.M., from the catalogue: Robert Motherwell, New York 1982

89 • Open No. 88. 1969. Acrylic on canvas. 54:60 inches, 137.5:152.5 cm.
90 • The Iron Flute. 1976. Acrylic and collage on canvas. 71¼:23¼ inches, 181:59.1 cm.
91 • In Scarlet and Black with Ultramarine Stripe. 1976. Acrylic and collage on canvas. 72:36 inches, 180:90 cm.
92 • Elegy to the Spanish Republic No. 160. 1979. Acrylic on canvas. 50:80 inches, 127:203 cm.

93 El Negro Book. 1981–83.
19 Lithographs by Robert Motherwell illuminating the Poem by Rafael Alberti, 9/51.
15:15 inches, 38.1:38.1 cm; 15:25¾ inches, 38.1:65.4 cm; 15:37¾ inches, 38.1:95.5 cm.

• illustration in this catalogue

89 Open No. 88. 1969. Acrylic on canvas. 54 : 60 inches

Motherwell

141

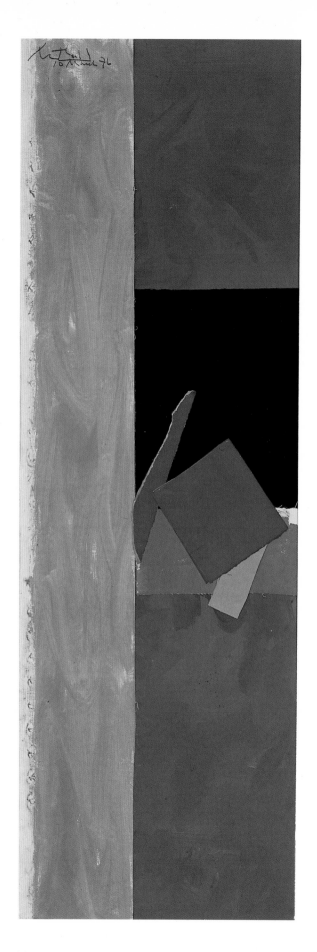

90
The Iron Flute. 1976
Acrylic and collage on canvas
71¼ : 23¼ inches

Motherwell

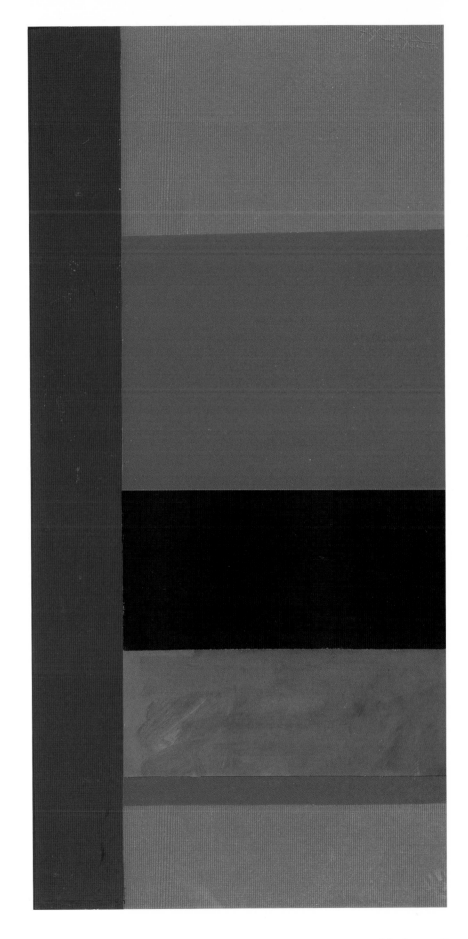

91
In Scarlet and Black with Ultramarine Stripe. 1976
Acrylic and collage on canvas
72:36 inches

Motherwell

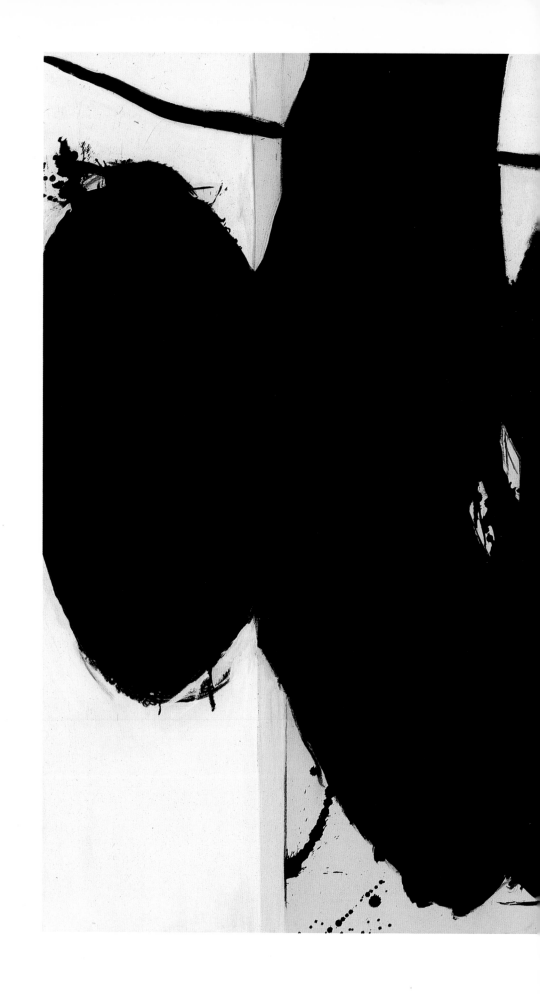

92
Elegy to the Spanish Republic No. 160. 1979
Acrylic on canvas
50 : 80 inches

Motherwell

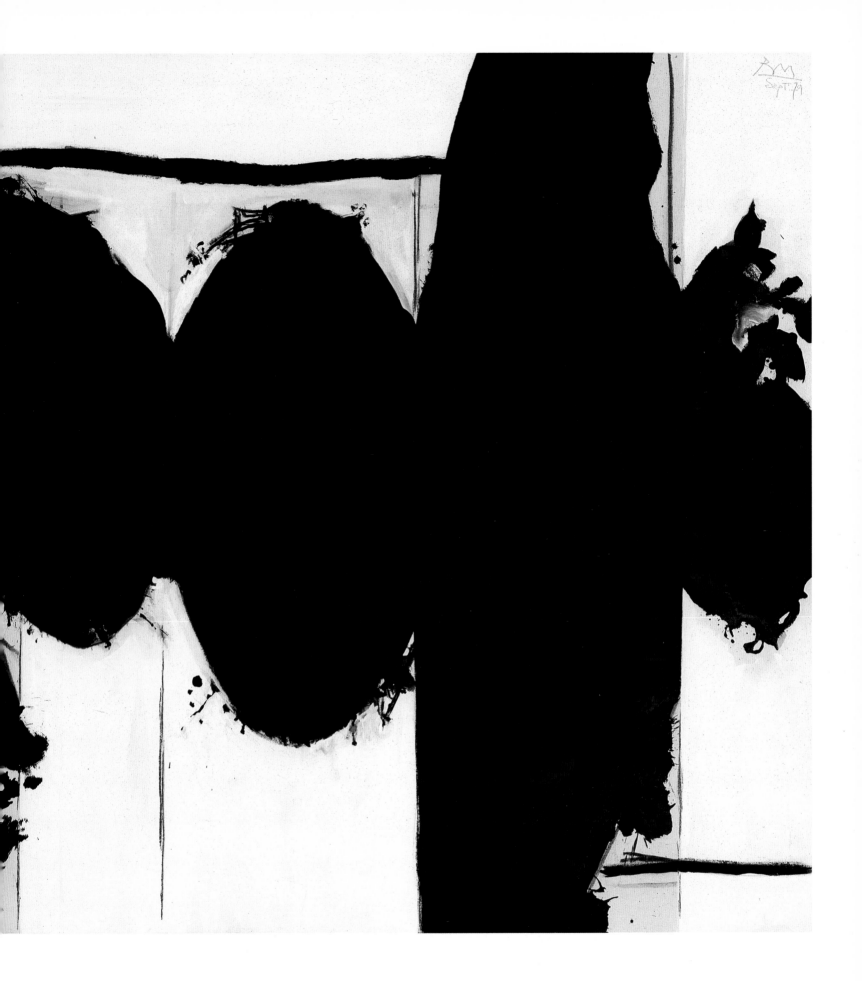

Markus Raetz

Raetz, Markus
Born 1941 in Büren an der Aare, Switzerland
Lives and works in Bern

1957–61 teacher training college in Bern. 1961–63 teacher in Brügg. Has worked as a freelance artist since 1963.

The Swiss artist uses a wide range of media. As painter, photographer, draughtsman, graphic artist and sculptor, he translates his observations of society into a critically conceptual art that is still never far from irony.

94 • Vlechtwerk. 1972. Ink on chalkpaper. 67¾:38¾ inches, 172:98.5 cm.
95 • in etwa. 1976. Ink and acrylic on cotton, in 4 parts. 32¼:25⅝ inches, 82:65 cm.
96 • Steinmann. 1977. Pencil, diluted ink and crayon on paper. 35½:24¾ inches, 90:63 cm.
97 • Bedeutende Linien. 1981. Watercolor and pastepaint, 7 parts. Each 18¼:24⅜ inches, 46:62 cm.

98 • Zwei Köpfe. 1978–80. Etched glass on maplewood. Edition of 3. 10¼:16½:22 inches, 26:42:56 cm.
99 • MIMI. 1980. 19 beechwood-elements. No.1 of a multiple-edition of 11. Various sizes.
100 • Samba für Johnny. 1982. 60 eucalyptus leaves. 20½:113⅜ inches, 52:288 cm.

• illustration in this catalogue

94
Vlechtwerk. 1972
Ink on chalkpaper
67¾ : 38¾ inches

Raetz

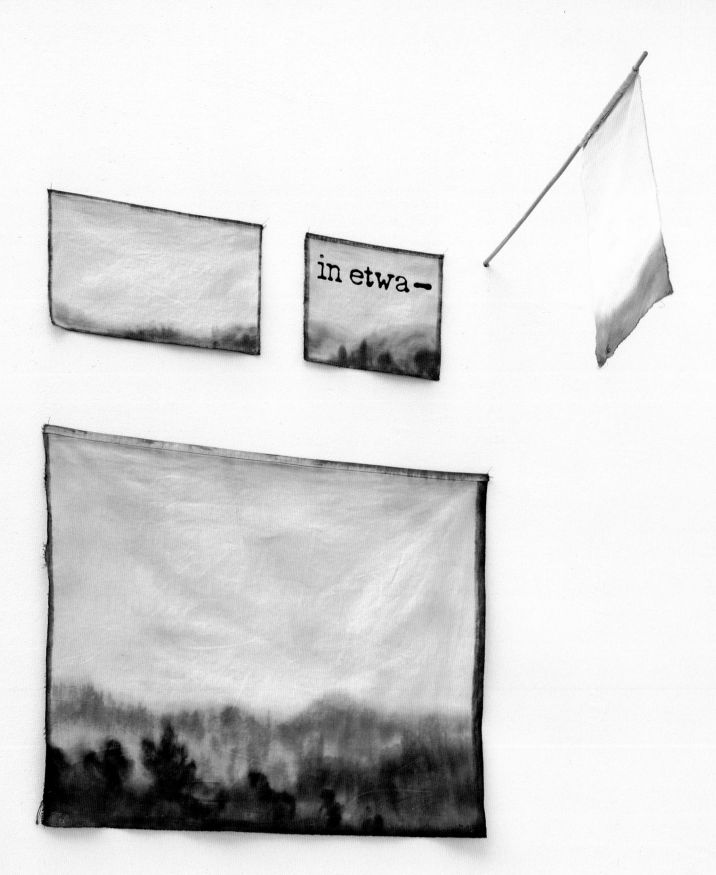

95
in etwa. 1976
Ink and acrylic on cotton
In 4 parts
32¼ : 25⅝ inches

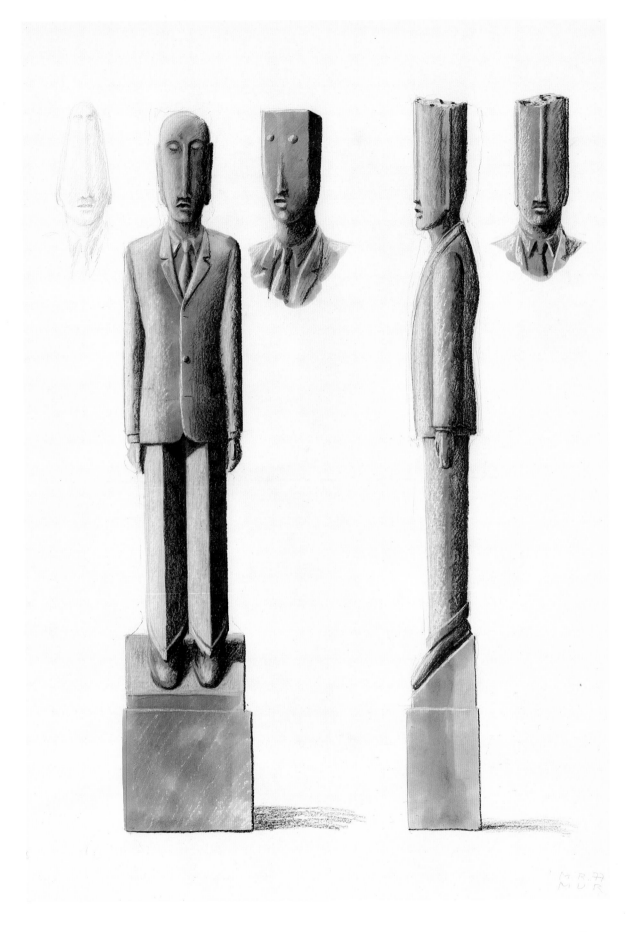

96
Steinmann. 1977
Pencil, diluted ink
and crayon on paper
35½ : 24¾ inches

Raetz

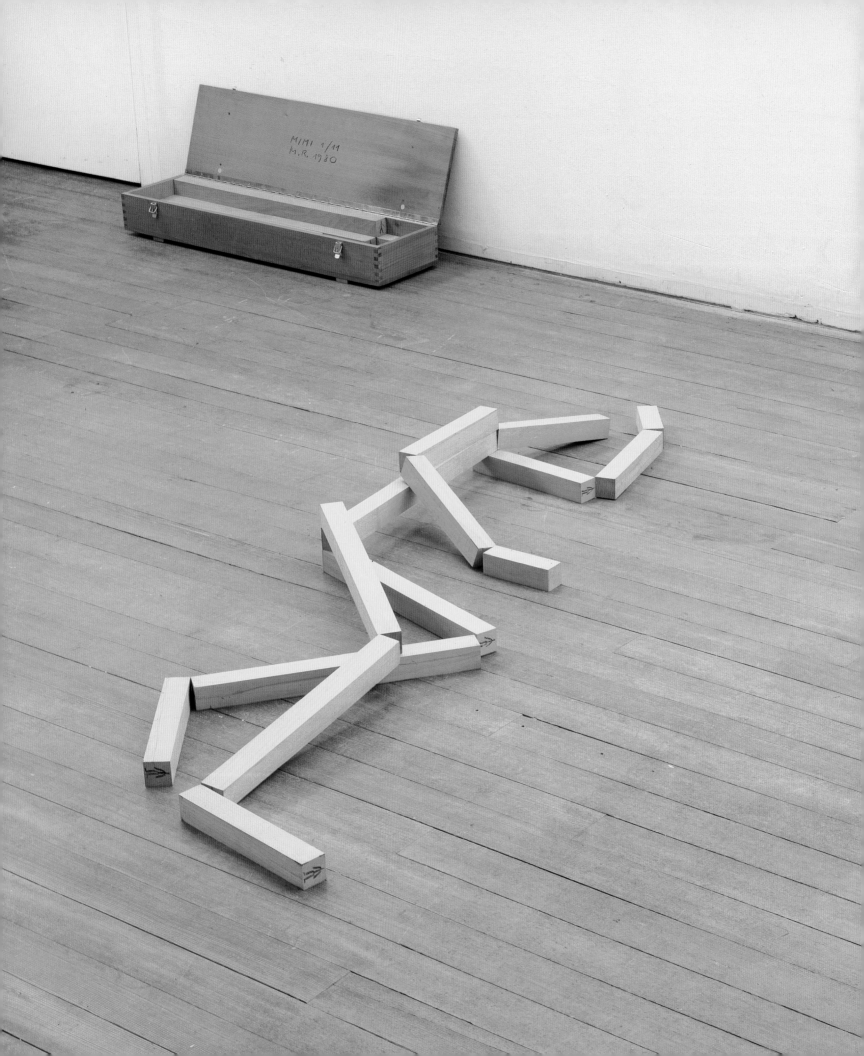

99
MIMI. 1980
19 beechwood elements
No. 1 of a multiple edition of 11
Various sizes

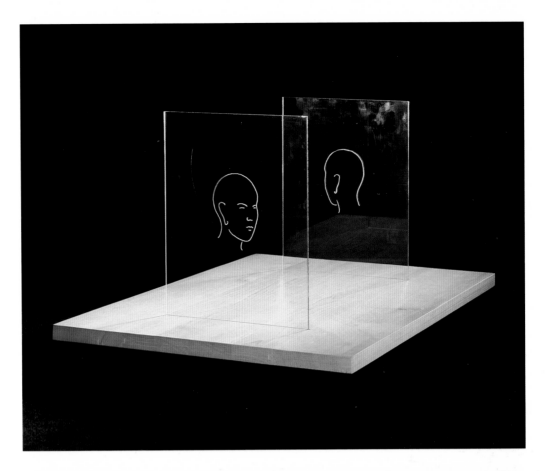

98
Zwei Köpfe. 1978–80
Etched glass on maplewood
Edition of 3
10¼ : 16½ : 22 inches

Raetz

97
Bedeutende Linien. 1981
Watercolor and pastepaint
7 parts, each 18¼ : 24⅜ inches

Raetz

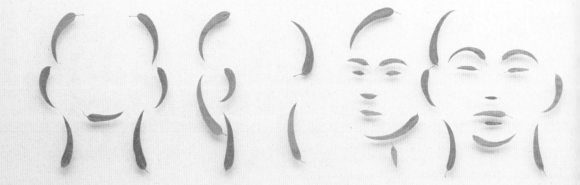

100
Samba für Johnny. 1982
60 eucalyptus leaves
20½ : 113⅜ inches

Raetz

156

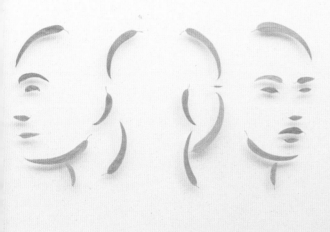

Arnulf Rainer

Rainer, Arnulf

Born 1929 in Baden, Austria
Lives and works in Vienna, Upper Austria and Bavaria

1947–49 attended the State Technical High School in Villach. 1949, Applied Arts University in Vienna, Academy of Fine Arts in Vienna. He quarrelled with his professors and left both University and Academy after a very short time. At an exhibition of the "Hundsgruppe" in Vienna in 1951, he shouted abuse at the visitors. 1953–59 exhibitions in the Gallery Nächst St. Stephan, Vienna (Director: Monsignore Mauer). 1963 ateliers in Germany (Berlin, Munich, Cologne). Professor at the Academy of Visual Arts in Vienna since 1981.

"Painting is a visual form of intellectual consciousness. The first perception of a point against the surrounding background was the moment of its birth. The infinite number of points (the undifferentiated surface) reduces it to nothing. By way of a continual reduction it strives for those marginal situations. (Distillation and dissolution.) To destroy the thousand-year-old idols, a tireless effort to achieve emancipation from a tradition of decay, the second oldest tradition there is.

 To leave this kind of world behind taking the example of painting, to unmask with its help its culture, its painting, without getting mixed up with it, to unmask it as a substitute for a lost or lacking metaphysical bond (in whose being there is neither action, nor mission, nor evidence, nor art), to reveal it as no more than a mere link between the aesthetic and the metaphysical. To be an artist and to despise art. ..."

101 • Blaue Übermalung. 1956. Oil on canvas. 27½:43¼ inches, 70:110 cm.
102 • Schwarze Übermalung. 1958. Oil on wood with aluminum frame. 32½:49¼ inches, 82.4:125 cm.
103 • Orange Übermalung. 1960. Oil on canvas with aluminum frame. 51⅛:31⅞ inches, 130:81 cm.
104 Untitled. 1962. Crayon on paper, mounted on aluminum plate (1977). 6⅝:7⅞ inches, 17:20 cm.
105 • Michelangelo. 1967. Oil on ultraphane. 46½:34⅝ inches, 118:88 cm.
106 Untitled. 1970. Crayon on graph paper. 11⅝:7⅞ inches, 30:20 cm.
107 • Rücken. 1974. Oil on paper. 20:28¾ inches, 51:73 cm.
108 • Untitled. 1978. Mixed media on photograph. 23⅞:19⅞ inches, 60.5:50.5 cm.
109 • Totenmaske. 1978. Mixed media on photograph. 23⅞:19 inches, 60.5:48.2 cm.
110 • Untitled. 1981. Oil on cardboard. 28⅞:40 inches, 73.2:102 cm.
111 • Untitled. 1981. Oil on cardboard. 28⅞:20 inches, 73.2:51 cm.

• illustration in this catalogue

A. R., 1952. From the catalogue: Arnulf Rainer, Berlin, Bonn, Baden-Baden, Vienna, 1981

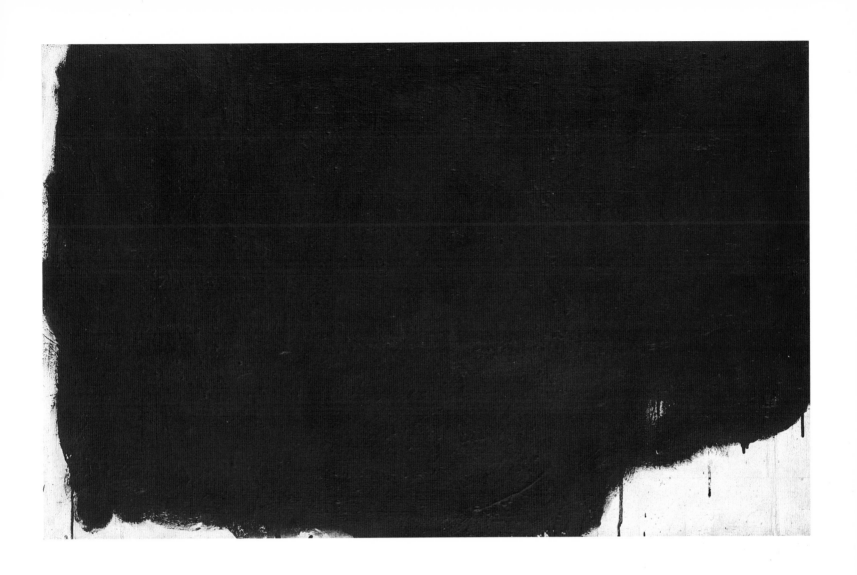

101 Blaue Übermalung. 1956. Oil on canvas. 27½ : 43¼ inches

Rainer

161

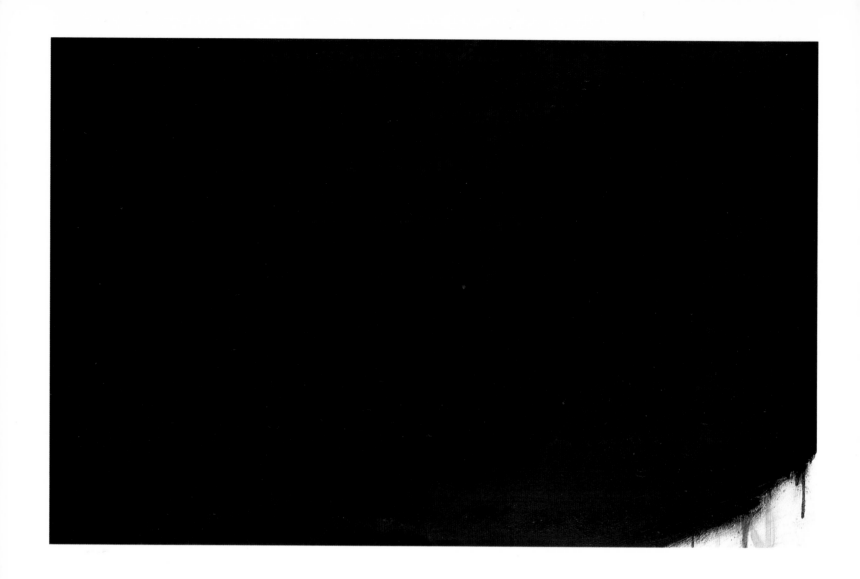

102
Schwarze Übermalung. 1958
Oil on wood with aluminum frame
32½ : 49¼ inches

Rainer

162

103
Orange Übermalung. 1960
Oil on canvas with aluminum frame
51⅛ : 31⅞ inches

Rainer

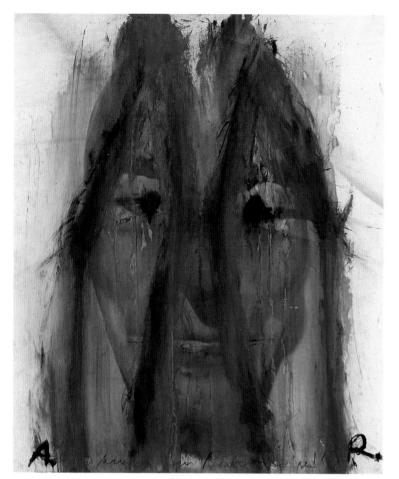 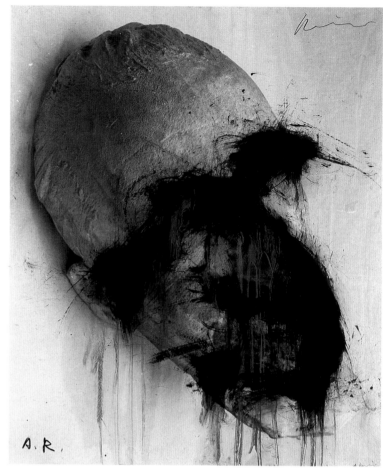

108
Untitled. 1978
Mixed media on photograph
23⅞ : 19⅞ inches

109
Totenmaske. 1978
Mixed media on photograph
23⅞ : 19 inches

Rainer

164

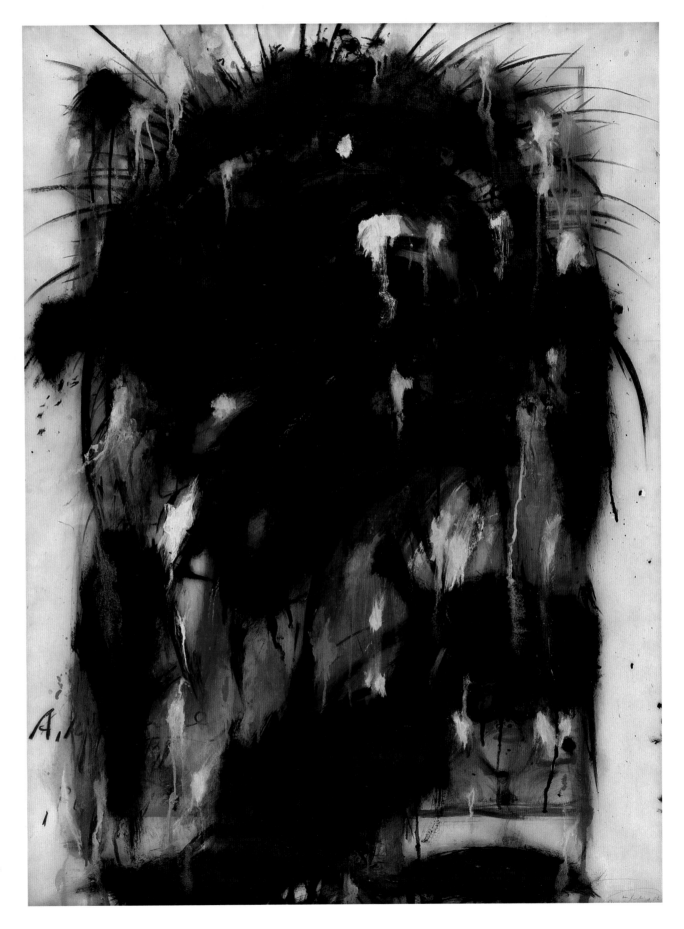

105
Michelangelo. 1967
Oil on ultraphane
46½ : 34⅝ inches

Rainer

111
Untitled. 1981
Oil on cardboard
28⅞ : 20 inches

Rainer

Gerhard Richter

Richter, Gerhard
Born 1932 in Dresden, Germany
Lives and works in Cologne

1951–56 studied at the Art Academy in Dresden, 1961 came over to Düsseldorf, 1961–63 studied at the National Academy of Art in Düsseldorf, since 1971 Professor there; 1983 moved to Cologne.

The West German artist works in a wide variety of different styles. His intellectual approach is transported by a very considerable painting talent. The perfection of the painting is a matter of the conception.

"... to think about the tool that enables me to create whatever I want. Red – blue – yellow (and light = white): pictures that emerge from the process. Three primary colours as a point of departure for an infinite series of nuances; either systematically multiplied tone by tone and perfectly represented (colour charts); or this man-made jungle, with colours and forms arising from the constant to and fro of the brush strokes, and creating illusionistic three-dimensionalities without my having to invent any forms or symbols. The brush follows its inevitable path from one patch of colour to the next, first mediating, then more or less destroying, mixing and mingling till not a single spot remains untouched, it's all one porridgy mix, an unresolvable imbroglio of form, space, and colour in equal proportions. Images that simply come into being, that come about as a result of what is going on, not creations, not creative in the way that phoney word is usually used (I say this because I detest the word), but certainly creatural. An illustration of the fascination that this jungle-like entanglement of forms has for me: as a child I used to draw with my finger in the grease left behind on my empty supper plate – loops and curves that constantly crossed and intersected with each other and formed fantastic three-dimensional structures that changed according to how the light fell on them and which could be spun out endlessly into ever new shapes and forms."

G. R. in a letter to Jean-Christophe Ammann, dated 24th February 1973
From the catalogue: Gerhard Richter, Düsseldorf – Vienna 1986 (Cologne 1986)

112 • S.D.I. 1986. Oil on canvas (2 parts). 126 : 157½ inches, 320 : 400 cm.

• illustration in this catalogues

112
S.D.I. 1986
Oil on canvas (2 parts)
126 : 157½ inches

Richter

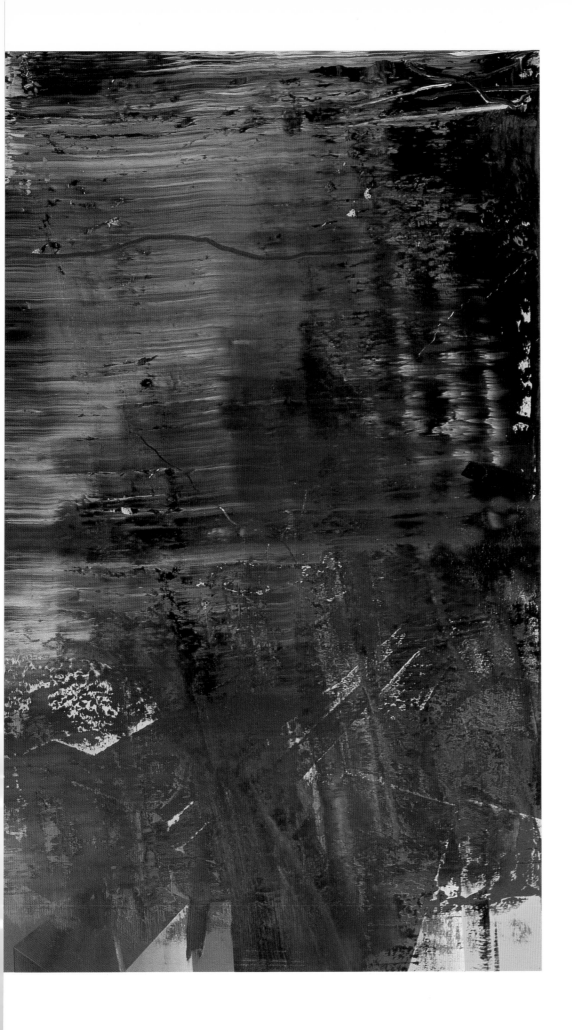

Robbins, Bruce

Born 1948 in Philadelphia, USA
Lives and works in New York

1968–69 spent time in Israel, 1969 travelled around Europe, since 1970 in New York; 1970–73 attended the Cooper Union School of Art and Architecture in New York; 1976 first exhibition in New York.

The American artist is a painter and a sculptor.

"I started to paint things out, and ended by painting things in ... I investigated how the truth of a phenomenon is often withheld by an appearance that has its own equally valid truth."

113 • Ladder. 1976. Oilpaint on aluminum, wood, canvas. 96:14:3 inches, 243.2:61:7.6 cm.
114 • Black Ladder. 1976. Oil, aluminum, wiremesh, plaster and wood. 96:14:2½ inches, 243.8:35.6:6.4 cm.
115 • White Plank. 1977. Oil, aluminum, wiremesh, plaster and wood. 96:14:2½ inches, 243.8:35.6:6.4 cm.
116 • Black and White Pilaster. 1978. Oil, bronze, encaustic on wood. 90:6:3 inches, 228.6:15.2:7.6 cm.
117 • Marker. 1982. Oil, wiremesh, canvas and aluminum on wood. 88:14:3 inches, 223.5:61:7.6 cm.
118 • Union Square. 1983. Oil, encaustic, plaster, aluminum, wiremesh and canvas on wood. 51½:51½:2¾ inches, 131:131.5:7 cm.
119 • Tower Slide. 1986. Poplar, plaster, aluminum, wiremesh. 128:33:14 inches, 325:84:35.5 cm.

120 Ladder Study I. 1976. Ink, pencil and wax on Arches paper. 9⅝:6½ inches, 24.4:16.5 cm.
121 Pilaster Study V. 1978. Ink, pencil and wax on Arches paper. 11:6⅞ inches, 28:17.5 cm.
122 Door Study I. 1979. Ink, pencil and wax on Arches paper. 11:6⅞ inches, 28:17.5 cm.
123 Torso. 1986. Oil, watercolor, pastel and graphite on Arches paper. 41½:29⅜ inches, 105.4:74.6 cm.
124 City Tower. 1986. Crayon and graphite on Arches paper. 41½:29⅜ inches, 105.4:74.6 cm.

• illustration in this catalogue

B. R., from the catalogue: Bruce Robbins, Zurich 1983/84

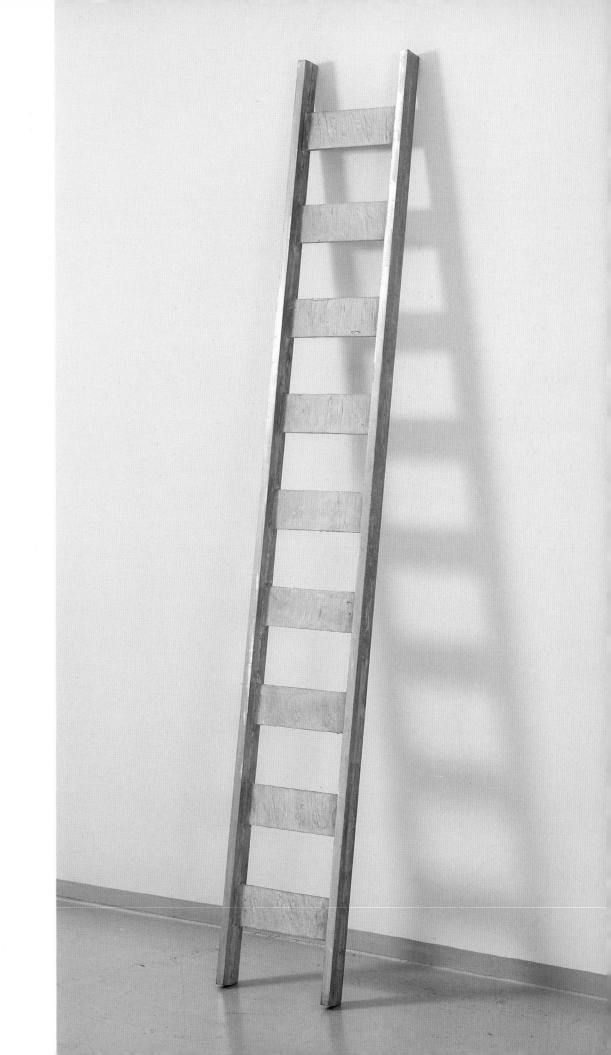

113
Ladder. 1976
Oilpaint on aluminum, wood, canvas
96 : 14 : 3 inches

Robbins

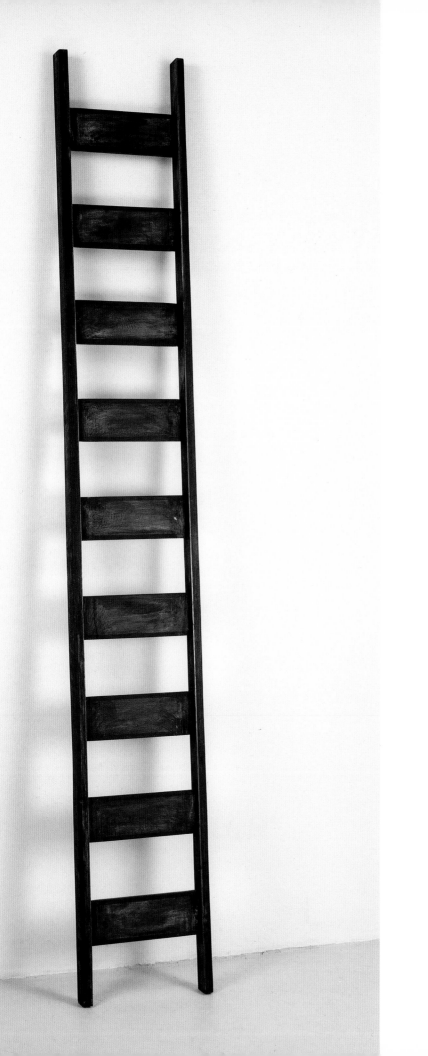

114
Black Ladder. 1976
Oil, aluminum, wiremesh, plaster and wood
96 : 14 : 2½ inches

Robbins

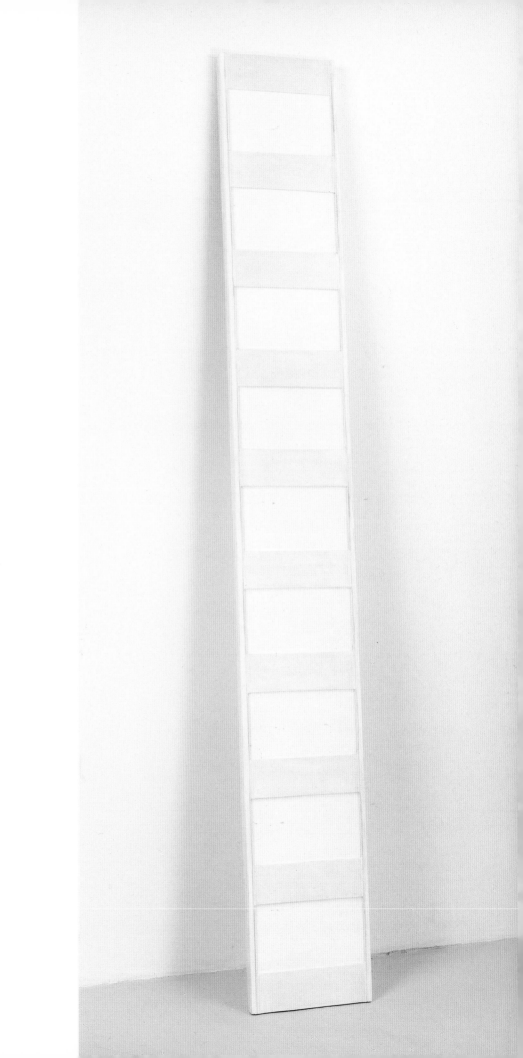

115
White Plank. 1977
Oil, aluminum, wiremesh, plaster and wood
96:14:2½ inches

Robbins

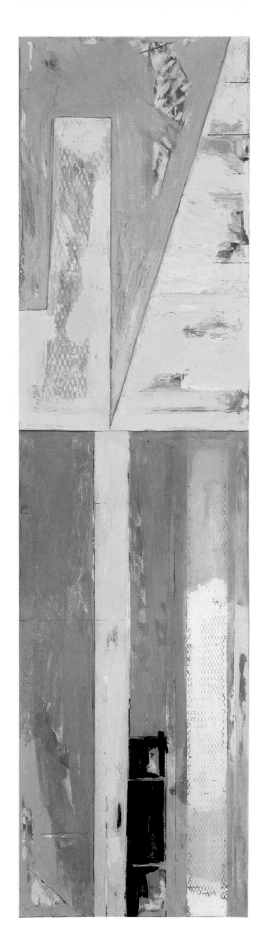

117
Marker. 1982
Oil, wiremesh, canvas and aluminum on wood
88:14:3 inches

Robbins

180

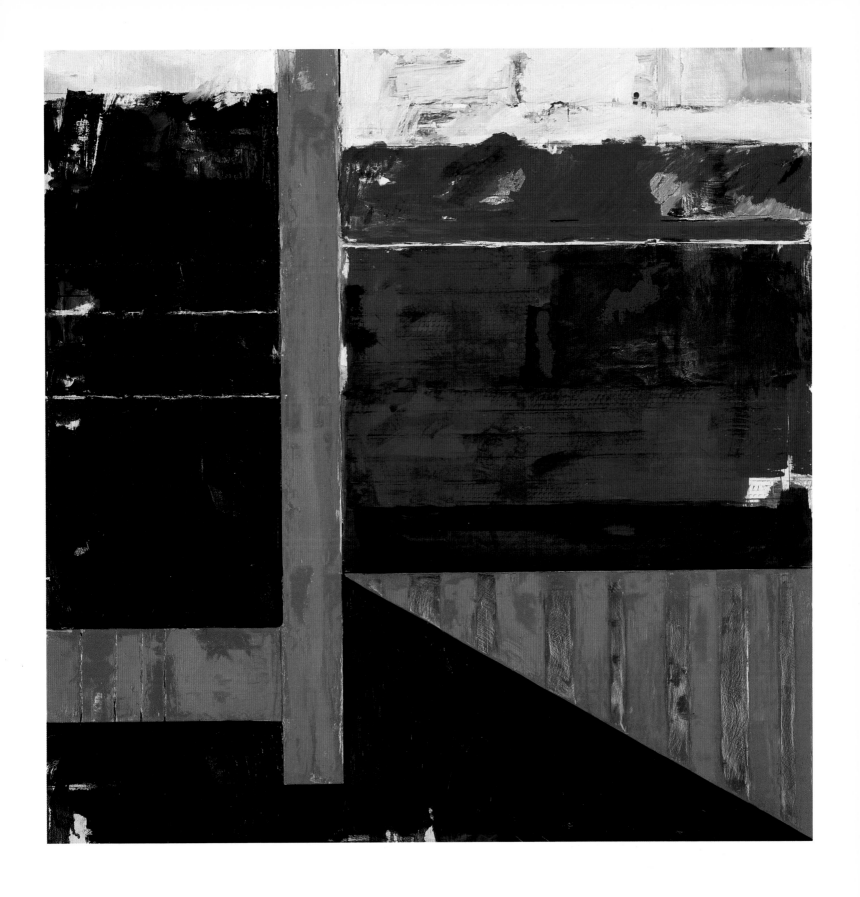

118 Union Square. 1983. Oil, encaustic, plaster, aluminum, wiremesh and canvas on wood. 51½ : 51½ : 2¾ inches

Robbins

181

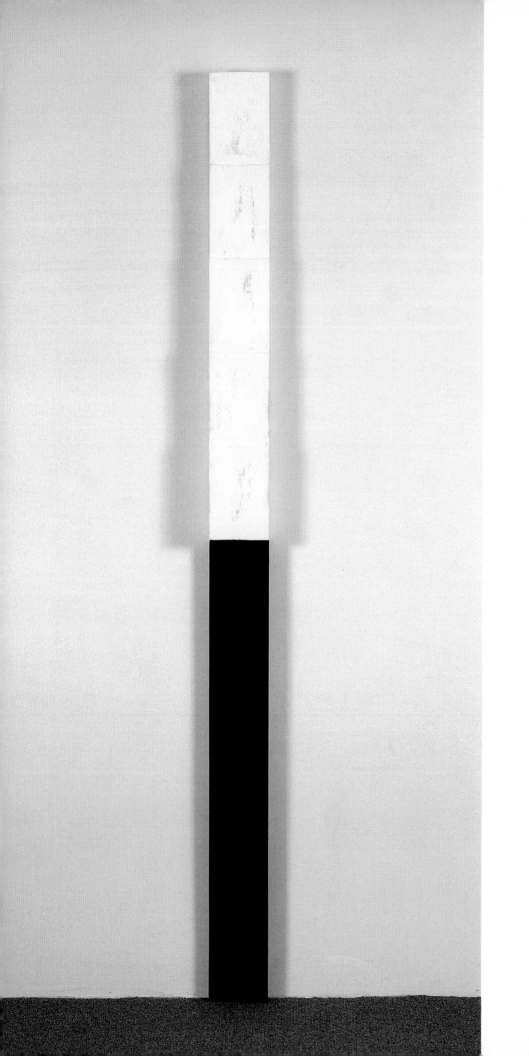

116
Black and White Pilaster. 1978
Oil, bronze, encaustic on wood
90 : 6 : 3 inches

Robbins

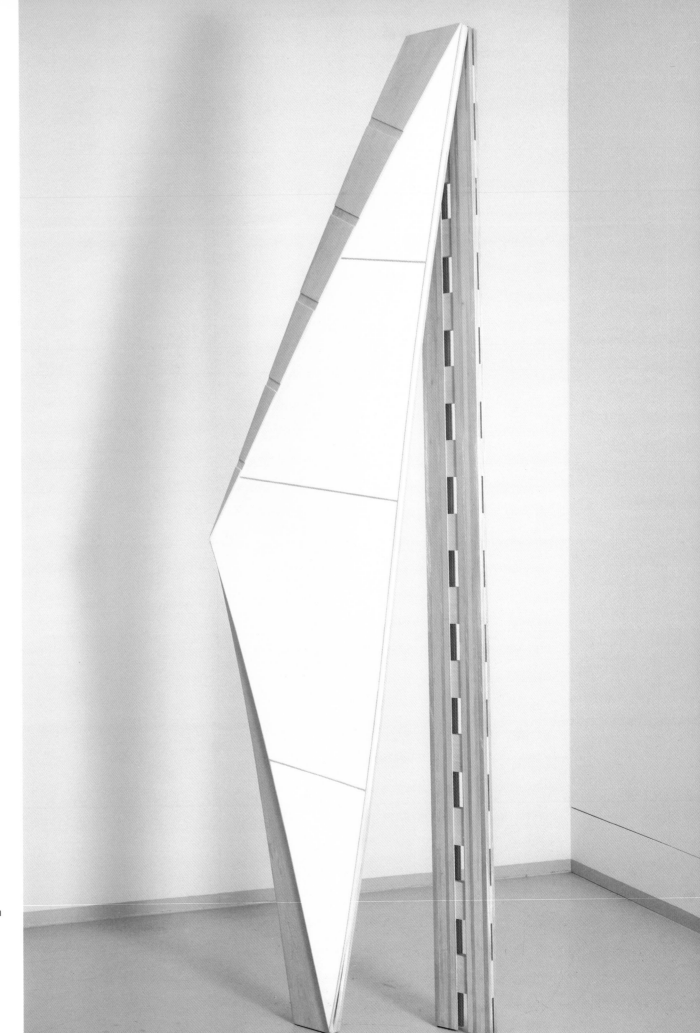

119
Tower Slide. 1986
Poplar, plaster,
aluminum, wiremesh
128:33:14 inches

Robbins

Soutter 127 Peintre et Modèle ou Vie de Rêve / Deux Nus (drawings on both sides). 1932/37. Ink on paper. 12⅝ : 10¼ inches

188

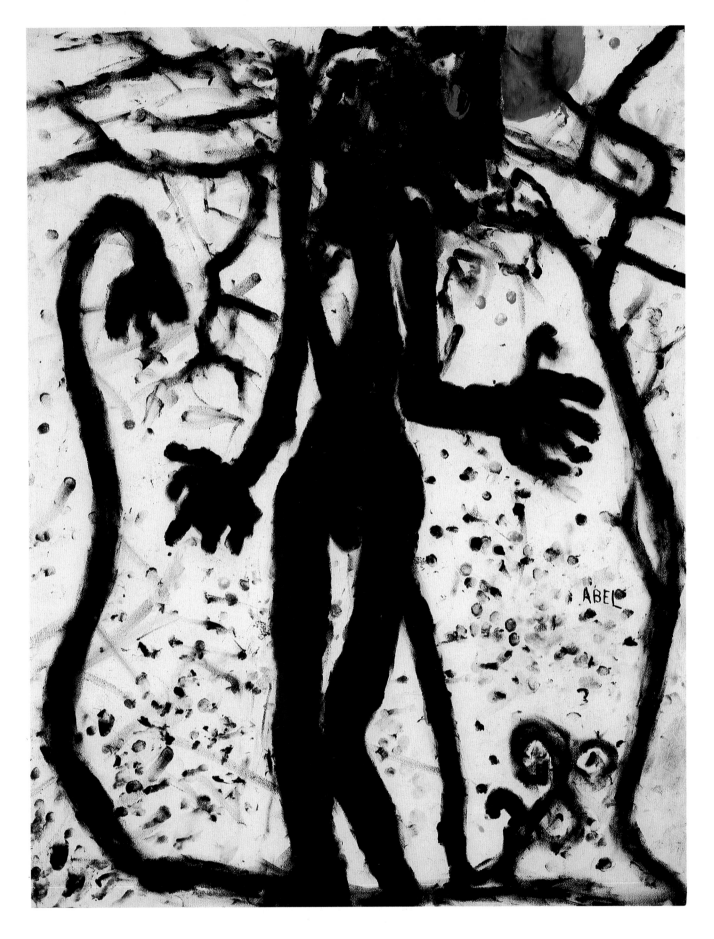

128 Abel. 1937/42. Printer's ink and gouache on paper. 25½:19⅝ inches

Soutter

Soutter 129 Perles Vives / Deux Nus et Deux Têtes d'Hommes (paintings on both sides). 1937/42. Ink on paper. 12¾ : 19⅝ inches

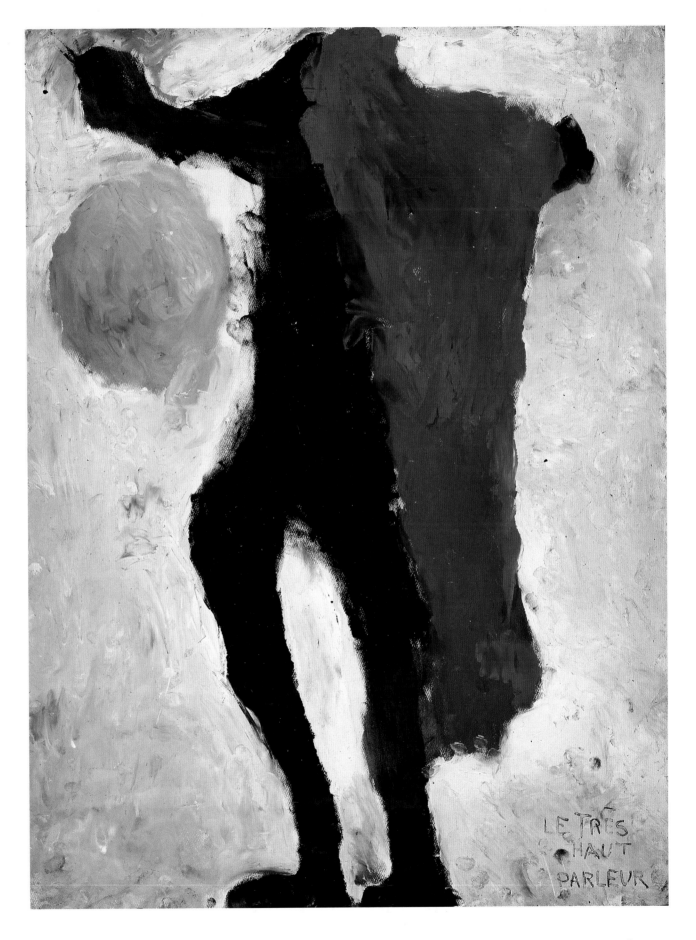

130 Le Très Haut Parleur de la Lune. 1939. Oil, gouache on paper. 23:17⅜ inches **Soutter**

Theodoros Stamos

Stamos, Theodoros

Born 1922 in New York, USA
Lives and works in New York and in Lefkas, Greece

Started drawing in 1930; 1936–39 attended the Peter Stuyvesant High School in Manhattan; started to study sculpture; had various jobs; 1941 opened a picture-framing shop in New York; 1947 met Mark Rothko; has held various teaching positions.

The American artist was the youngest member of the American School of Abstract Expressionists. He was a particularly close friend of Mark Rothko.

"To achieve the inner vision, the eastern artist tried to become the object itself. In other words, if a painter is involved with bamboos for ten years, eventually he becomes a bamboo, and then forgets all about the bamboo he is painting.

What matters is the concentration of thought and the prompt and vigorous action of the hand to the directing will. Such a response seems like a kind of automatic writing but the Oriental in possession of an infallible technique places himself at the mercy of inspiration ... Such an approach draws one close to Pantheism, but it must be faced that for the painter there exists a spiritual power which communicates life and meaning to material forms and that he must achieve this power before taking part in the elaboration of forms."

131 • Pass of Thermophylae. 1949. Oil on masonite. 39¾:24⅝ inches, 101:62.5 cm.
132 • Levant. 1956. Oil on cotton. 85:65 inches, 216:166 cm.
133 • Edge of Grey. 1957. Acrylic and oil on cotton. 60:70 inches, 152.4:177.8 cm.
134 • Tundra. 1959. Acrylic and oil on cotton. 60:70 inches, 152.4:177.8 cm.
135 • Very Low Sun-Box. 1964/65. Acrylic and oil on cotton. 56:68 inches, 142.5:173 cm.
136 • Infinity Field Lefkada Series. 1973. Acrylic on cotton. 90:69 inches, 228.6:175.2 cm.
137 • Infinity Field Creten Rizitika Series. 1983. Acrylic on cotton. 66:60 inches, 168:152.4 cm.
138 • Infinity Field Torino Series IX. 1985. Acrylic on cotton. 68:60 inches, 173:152.4 cm.

• illustration in this catalogue

T. S., from the catalogue: Theodoros Stamos, Zurich 1984

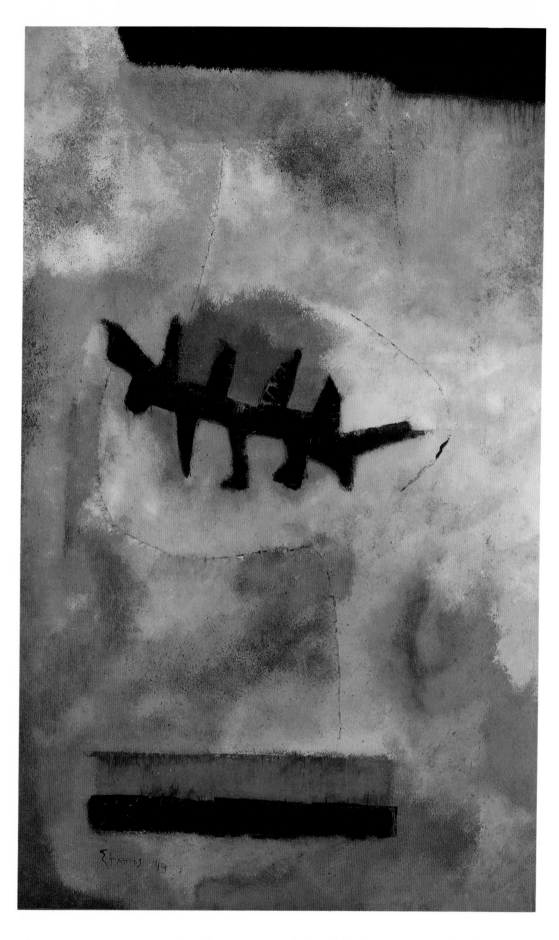

Stamos 131 Pass of Thermophylae. 1949. Oil on masonite. 39¾ : 24⅝ inches

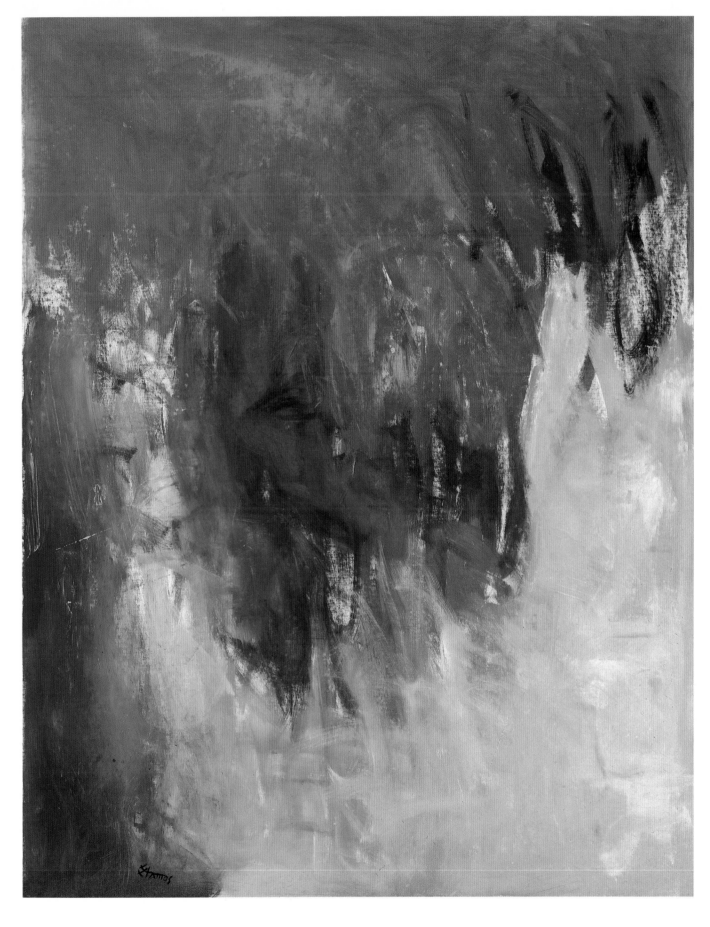

132 Levant. 1956. Oil on cotton. 85:65 inches

Stamos

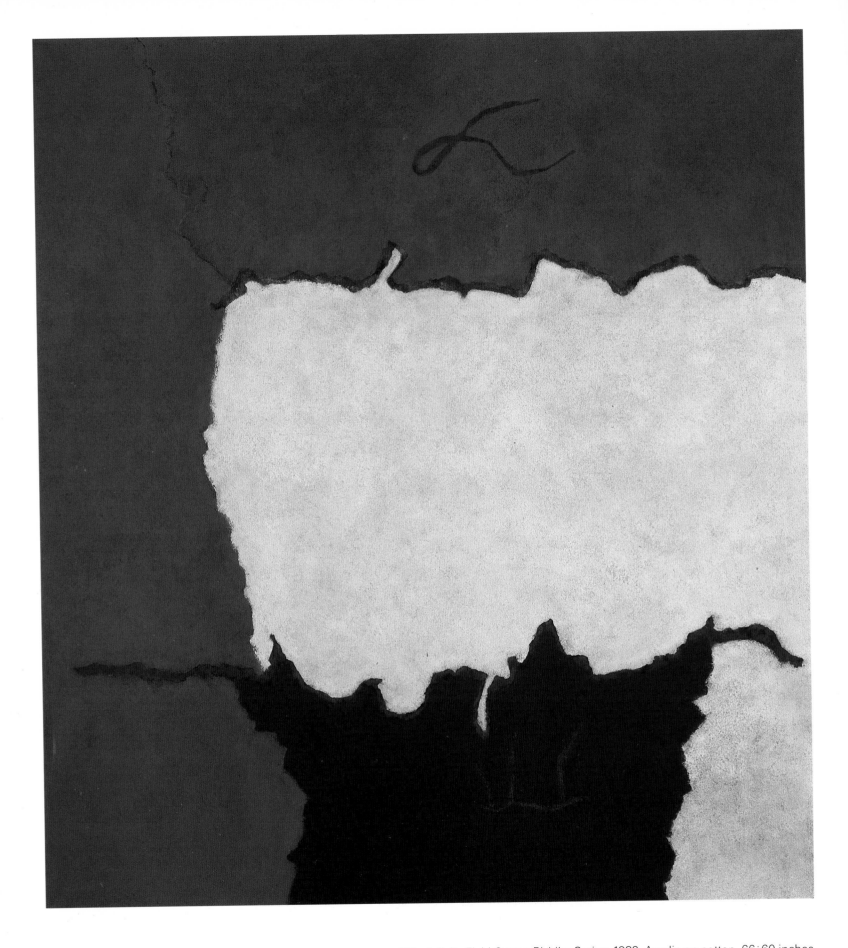

137 Infinity Field Creten Rizitika Series. 1983. Acrylic on cotton. 66:60 inches

138 Infinity Field Torino Series IX. 1985. Acrylic on cotton. 68:60 inches

Stamos

Stella, Frank

Born 1936 in Malden, Massachusetts, USA
Lives and works in New York

1950–54 Phillips Academy, Andover;
1954–58 studied History and
Art at Princeton University; 1958
moved to New York.

The American artist is a painter,
sculptor, theoretician and teacher.
He overthrows traditional definitions
and demarcation lines in his paint-
ings. His non-relational approach
does away completely with tradi-
tional academic principles of com-
position.

"I need something that I feel is
worth painting on, so I have to make
it myself... You can only take advan-
tage of those gifts that you really
have – that are part of your charac-
ter, I guess – and you're lucky to be
born with those gifts. I have a gift for
structure, and the strength of all the
paintings I made in the sixties lay in
their organization, their sense of
what pictorial structure could be.
Struggling through the Polish
pictures opened things up for me so
that I was able to use my gift for
structure with something that mod-
ernism hadn't really exploited be-
fore, the idea that paintings could
be constructed, made by picture-
building... Building a picture was
something natural for me. Build it
and then paint it. It was a job I was
well suited for."

139 • Sacramento Moposol No. 5 (Concentric Squares). 1978. Oil on canvas.
103:103 inches, 262:262 cm.
140 • Silverstone II. 1982. Mixed media on aluminum. 111:126:24 inches, 282:320:61 cm.

141 • Aluminum Series: Newstead Abbey. 1970. Lithograph 26/75 on Arjomari paper.
16:22 inches, 40.6:55.9 cm.
142 • Copper Series: Lake City. 1970. Lithograph 26/75 on Arjomari paper.
16:22 inches, 40.6:55.9 cm.
143 Multicolored Squares I: Sharpesville. 1972. Offset lithograph 45/100 on J. Green
mould-made paper. 16:22 inches, 40.6:55.9 cm.
144 Multicolored Squares I: Cipango. 1972. Offset lithograph 45/100 on J. Green
mould-made paper. 16:22 inches, 40.6:55.9 cm.
145 Jasper's Dilemma. 1973. Offset lithograph 55/100 on J. Green mould-made paper.
16:22 inches, 40.6:55.9 cm.
146 Jasper's Dilemma: Line Up. 1973. Offset lithograph 55/100 on J. Green mould-made
paper. 16:22 inches, 40.6:55.9 cm.
147 Les Indes Galantes III. 1973. Offset lithograph 55/100 on J. Green mould-made paper.
16:22 inches, 40.6:55.9 cm.
148 Les Indes Galantes IV. 1973. Offset lithograph 55/100 on J. Green mould-made paper.
16:22 inches, 40.6:55.9 cm.
149 • Sinjerli Variations II. 1977. Offset lithograph and screenprint 52/100 on Arches paper.
32:42½ inches, 81.3:107.9 cm.
150 Sinjerli Variations III. 1977. Offset lithograph and screenprint 52/100 on Arches paper.
32:42½ inches, 81.3:107.9 cm.
151 • Swan Engraving IV. 1983. Lithograph 9/30. 66:52 inches, 167.6:132 cm.

• illustration in this catalogue

F. S., from the catalogue: Frank Stella,
New York 1987

151 Swan Engraving IV. 1983. Lithograph 9/30. 66:52 inches

Stella

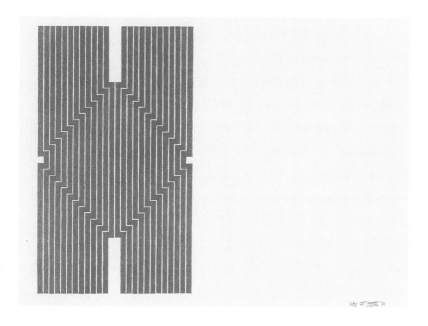

141
Aluminum Series: Newstead Abbey. 1970
Lithograph 26/75 on Arjomari paper
16:22 inches

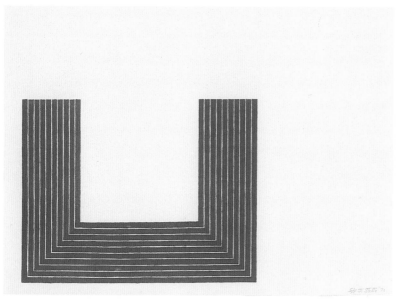

142
Copper Series: Lake City. 1970
Lithograph 26/75 on Arjomari paper
16:22 inches

Stella

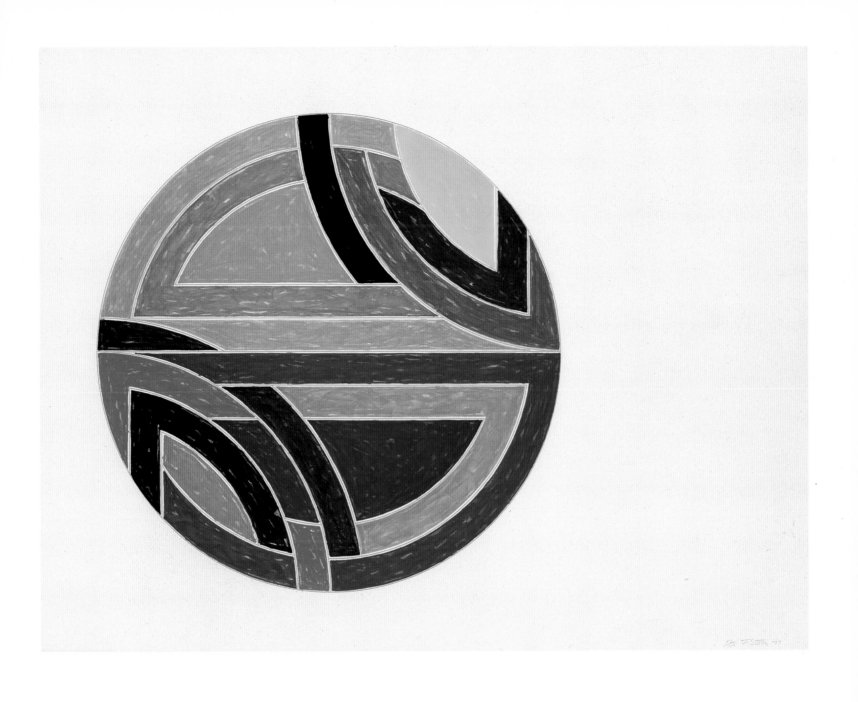

149 Sinjerli Variations II. 1977. Offset lithograph and screenprint 52/100 on Arches paper. 32 : 42½ inches

Stella

139
Sacramento Moposol No. 5 (Concentric Squares). 1978
Oil on canvas
103 : 103 inches

Stella

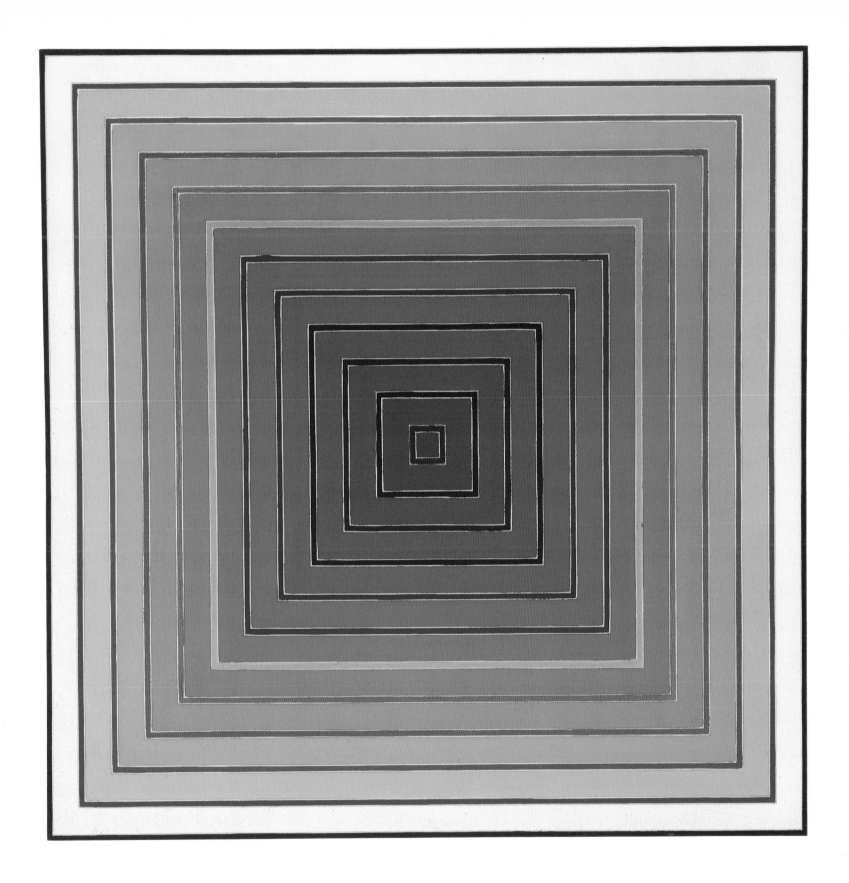

140
Silverstone II. 1982
Mixed media on aluminum
111:126:24 inches

Stella

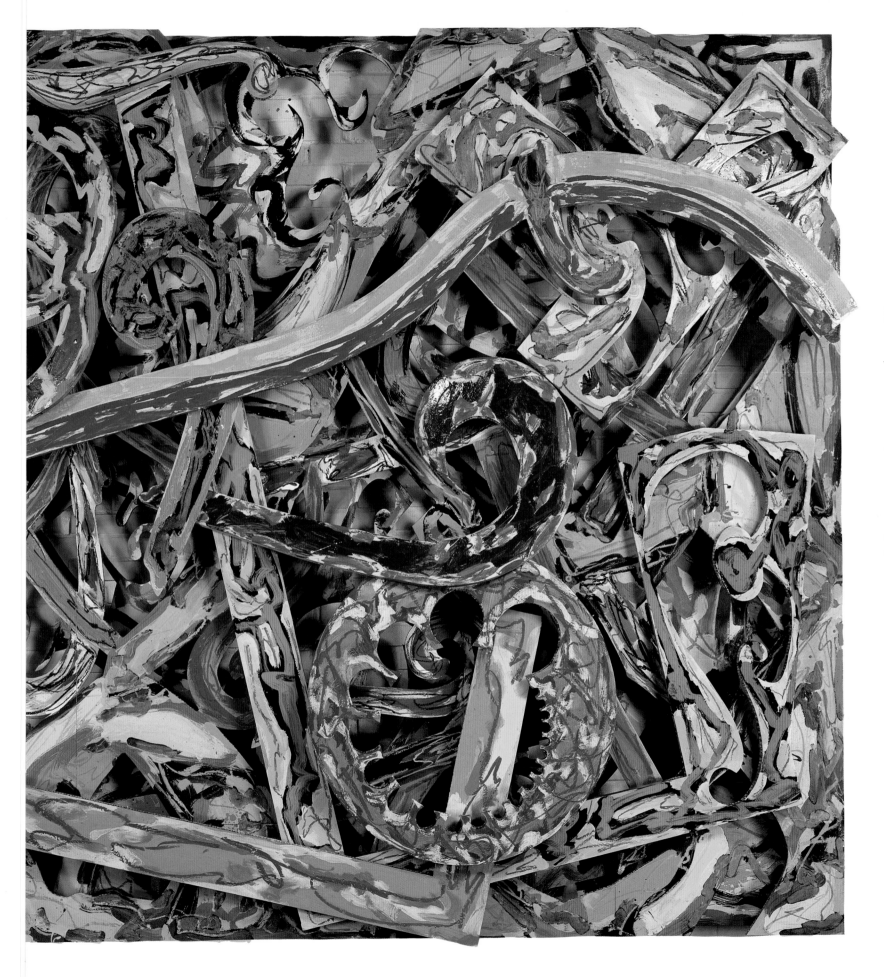

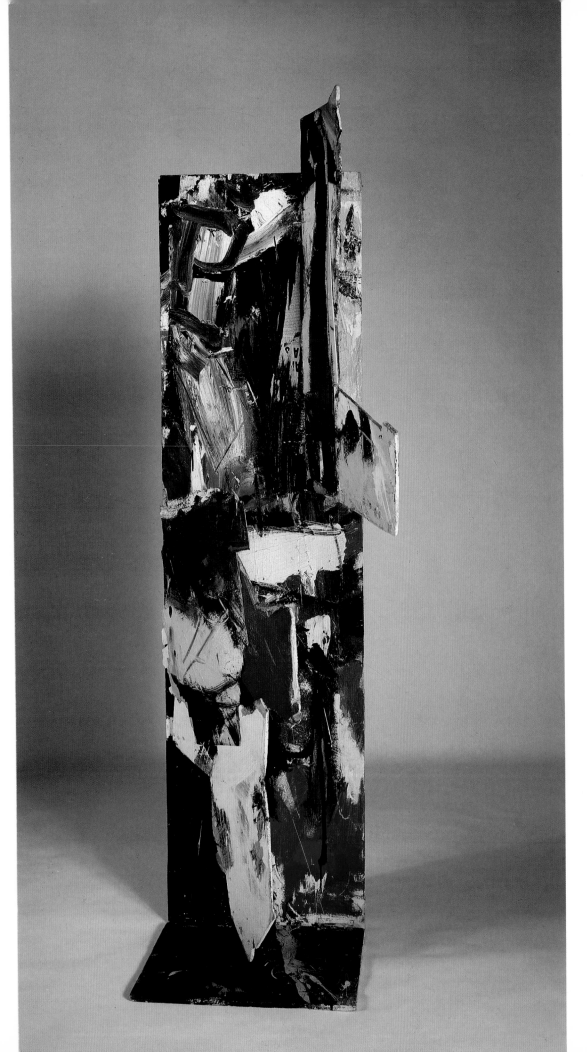

152
Plurimo No. 6 ''Nego''. 1962/63
Oilpaint on wood with iron
Height: 84 inches

Vedova

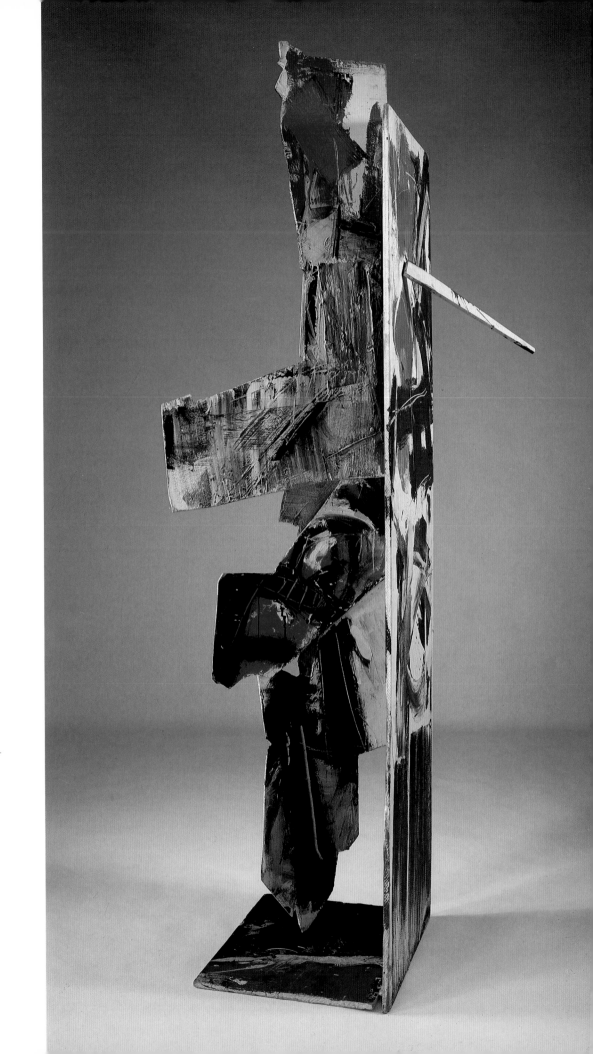

152
Plurimo No. 6 "Nego". 1962/63
Oilpaint on wood with iron
Height: 84 inches

Vedova

Bill, Max

Born 1908 in Winterthur, Switzerland
Lives and works in Zurich

1924–29 studied at the College of
Commercial Art in Zurich; 1927–29
studied at the Bauhaus in Dessau;
returned to Zurich in 1929 and has
worked there ever since.

In his activities as architect,
painter, sculptor, graphic artist, poli-
tician and journalist, the Swiss artist
tirelessly champions the cause of an
art that is relevant to our day, to a
life that is dominated and deter-
mined by the sciences. His art does
not herald danger from the new
knowledge, but promises its moral
and progressive permeation as the
expression of a new humanity.

"Concrete Art is the designation we
use for those works of art that have
been created without any reference
to the world outside, to natural
phenomena or any transformations
– or abstractions – of the same,
but which arise out of their own
immanent laws and conditions.

Concrete Art is independent by
nature. It is an expression of the
human spirit, and its addressee is
the human spirit. And it should be
characterized by such acuteness,
unequivocalness and perfection as
can be expected of works of the
human spirit.

Concrete painting and sculpture
give form to what can be optically
perceived. Their materials are
colour, space, light and movement.
The moulding of these elements
allows new realities to take shape.
Abstract ideas that have existed
hitherto only in the imagination are
made visible in concrete form.

Concrete Art is ultimately the pure
expression of harmony, measure
and law. It orders systems and with
artistic means gives life to this order.
It is real and spiritual, unnaturalistic
and yet close to nature. It aspires to
the universal and yet cultivates the
unique. It subjugates the individual-
istic in favour of the individual."
(1936–49)

M. B., from the catalogue: Max Bill,
Frankfurt 1987

155 • Einheiten aus drei gleichen Volumen. 1961. Chromium-plated brass.
10¼:17:12½ inches, 26:43:32 cm.
156 • Extension of Parallels. 1970. Oil on canvas. 67:67 inches, 170:170 cm.

• illustration in this catalogue

155
Einheiten aus drei gleichen Volumen. 1961
Chromium-plated brass
10¼:17:12½ inches

222

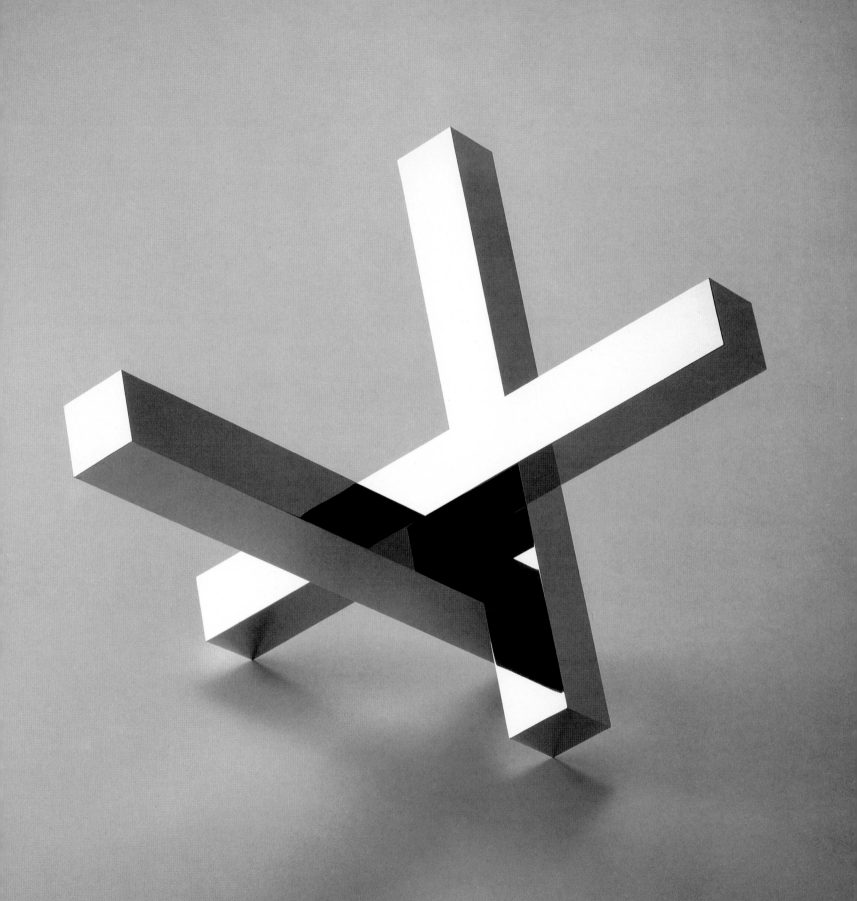

156
Extension of Parallels. 1970
Oil on canvas
67:67 inches

Bill

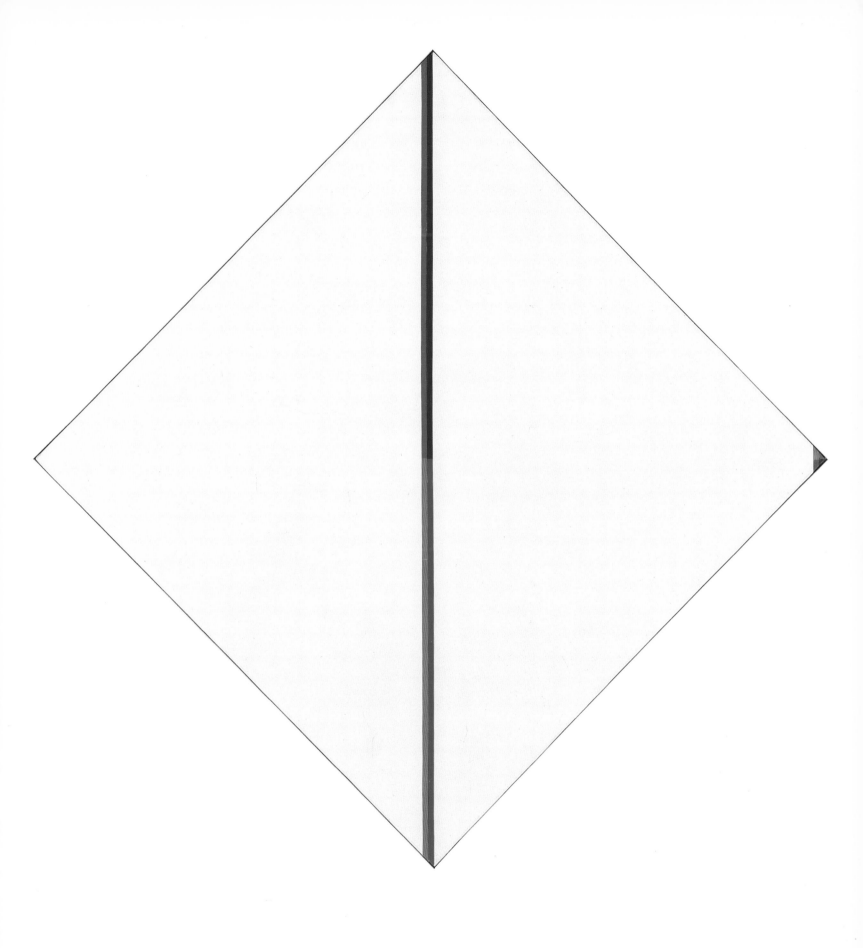

Glarner, Fritz

Born 1899 in Zurich, Switzerland
Died 1972 in Locarno

Spent his childhood in Naples, Paris and Chartres. 1914–20 student at the Regio Istituto di Belle Arte in Naples; moved to Paris in 1923, Zurich 1935–36, went to the United States in 1936, lived in New York and Huntingdon, Long Island; American citizen since 1944, moved to Locarno in 1971.

The Swiss-American artist was a friend of Piet Mondrian. His compositions are more cheerful than those of the Dutch artist. His paintings are systematic, integrated, so to speak, into the new sciences and at the same time an expression of them.

"The formal symbol of the circle is obliterated because form and space are created within it.

The artist today has to create the new conditions in which the pure painterly means can reveal their true expression.

The visual arts of the past achieved integration in a naturalistic and physical way: painting, for example, in the fresco and sculpture in the relief.

It is my firm belief that we are living in a developmental phase. Truth will reveal itself to us more clearly through new equivalents that will arise from the integration of the visual arts. The new essential integration is already perceptible.

Relational painting – a gradual development in the direction of the essential integration of all the visual arts."

F. G., from the catalogue: Fritz Glarner, Bern 1972

157 Etudes. 1929/30. Oil on canvas. 28¾ : 23⅝ inches, 73 : 60 cm.
158 • Relational Painting Tondo No. 18. 1950/51. Oil on fibreboard. Diameter: 49¼ inches, 125 cm.
159 • Study for a wallpainting. 1958/62. Color drawing on paper. 11⅞ : 25⅜ inches, 30 : 64.5 cm.

• illustration in this catalogue

159 Study for a wallpainting. 1958/62. Color drawing on paper. 11⅞ : 25⅜ inches

Glarner

158
Relational Painting Tondo No. 18. 1950/51
Oil on fibreboard
Diameter: 49¼ inches

Glarner

229

Graeser, Camille

Born 1892 in Carouge-Genève, Switzerland
Died 1980 in Zurich

1913–15 studied interior design at
the College of Commercial Art
in Stuttgart; 1918 Atelier for Interior
Design in Stuttgart; 1926–27 contact
with Mies van der Rohe; 1933 de-
struction of a large number of his
works; returned to Switzerland.

The Swiss painter, graphic artist
and interior designer dreamed of an
art without illusion, of an art that
would be better defined as an inter-
pretation of the world. His construc-
tions represent a new perception,
a better life, showing other possibil-
ities without illusion despite dis-
locations.

"Concrete art does not reproduce,
it creates itself autonomously out of
itself. It should therefore be regarded
as being on a par with music, since
it creates symphonic sounds for the
eye, particularly for those eyes that
can hear."

160 Construction. 1945/48. Ink on paper. 13⅞:20 inches, 35.1:51 cm.
161 • Tanslokation II. 1969. Oil on canvas. 47¼:47¼ inches, 120:120 cm.
162 • Disloziertes Weiss. 1971. Oil on canvas. 39⅜:39⅜ inches, 100:100 cm.

• illustration in this catalogue

C.G., Optical Music, 1949
From the catalogue: Camille Graeser,
Zurich 1982

230

162 Disloziertes Weiss. 1971. Oil on canvas. 39⅜ : 39⅜ inches

Graeser

161
Translokation II. 1969
Oil on canvas
47¼ : 47¼ inches

Graeser

Lohse, Richard Paul
Born 1902 in Zurich, Switzerland
Died 1988 in Zurich

1917 paintings of his local surroundings; 1922–27 worked in an advertising studio; 1933 got to know Paul Klee; 1940 pictographs over diagonal, vertical and horizontal structures; investigations of the interrelationship between art and architecture.

The Swiss artist was a painter, a planning architect, and above all one of the main theoreticians of the Zurich group of Concrete Artists (together with Bill, Glarner, Graeser and Loewensberg). His paintings are operational actions in pursuit of a visual theme without illusionistic and semantic character. They are not imitations of existing entities, but new creations.

"In order to obtain new operative fundamentals, it was necessary to systematize the means in such a way that they could form logical sequences and make possible a large number of operations. The result was variability and extendability.

With the development of systematically ordered groups comes the problem of the colour progression; form structure becomes colour structure.

The colour sequence establishes the rules for the formal expression; colour and form as opposites cancel each other out.

It becomes possible to construct logical sequences of structure, which give rise to an unlimited, predetermined sequence of colours..."

R. P. L., Entwicklungslinien 1943–1985
From the catalogue: Richard Paul Lohse,
Vienna 1986

164 • Neun vertikale systematische Farbreihen mit horizontaler und vertikaler Verdichtung. 1955/69. Oil on canvas. 47¼ : 47¼ inches, 120 : 120 cm.

• illustration in this catalogue

164 Neun vertikale systematische Farbreihen mit horizontaler und vertikaler Verdichtung. 1955/69. Oil on canvas. 47¼ : 47¼ inches

Lohse

237

Dieter Ronte

1943	born in Leipzig, Germany
1962	School-leaving examination in Bochum, West Germany
1962–70	Studied art history, archaeology and Romance languages in Münster/Westphalia, Pavia, Rome/Italy
1970	Dissertation on Nazarenes and Dante in Münster/Westphalia
1971–79	Collaborator with the Cologne Museums
since 1979	Director of the Museum of Modern Art in Vienna, Austria
since 1988	Visiting professor at the Academy of Applied Arts in Vienna, Austria
	Numerous exhibitions and publications in different countries, especially on the Art of the 20th Century

Imprint

Distributed by Harry N. Abrams, Inc., New York

Conception: Donald M. Hess, Bern, and Eugen Götz-Gee, Bern
Translation into English with the exception of some artist's quotations:
Dr. Hilary Heltay, Cologne
Editorial collaboration: Corrado F. Ferrari, Zurich
ADD-Design: Eugen Götz-Gee, art director, Bern
Photographs: Beat Jost, Bern; G. Kathrein, Zurich; Jochen Littkemann, Berlin
Art reproductions: Charles Baum, Henzi Ltd., Bern
Printing and bookbinding: Stämpfli+Cie, Ltd., Bern

Printed in Switzerland